# DISCOVERING PRINC

## A Photographic Guide with Five Walking Tours

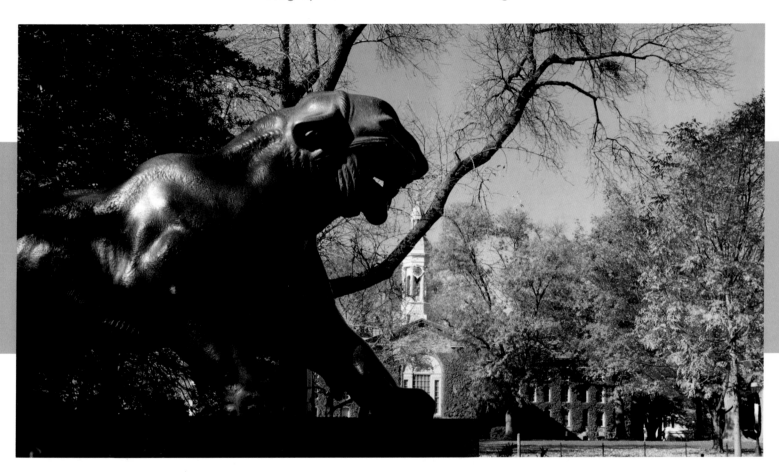

Wiebke Martens | Jennifer Jang

*Schiffer Publishing Ltd*

4880 Lower Valley Road • Atglen, PA 19310

**Other Schiffer Books on Related Subjects:**

*Princeton: History and Architecture*, Marilyn Menago, ISBN 978-0-7643-2626-4

*Olmsted Parks in New Jersey*, Jeanne Kolva, ISBN 978-0-7643-3872-4

*Pinelands: New Jersey's Suburban Wilderness*, Alfred D. Horner, ISBN 978-0-7643-4881-5

Copyright © 2017 by Wiebke Martens and Jennifer Jang

Library of Congress Control Number: 2016960236

All rights reserved. No part of this work may be reproduced or used in any form or by any means—graphic, electronic, or mechanical, including photocopying or information storage and retrieval systems—without written permission from the publisher.

The scanning, uploading, and distribution of this book or any part thereof via the Internet or any other means without the permission of the publisher is illegal and punishable by law. Please purchase only authorized editions and do not participate in or encourage the electronic piracy of copyrighted materials.

"Schiffer," "Schiffer Publishing, Ltd.," and the pen and inkwell logo are registered trademarks of Schiffer Publishing, Ltd.

Designed by Justin Watkinson
Cover design by Brenda McCallum

Type set in Argus/Minion Pro/Gothic720 BT

ISBN: 978-0-7643-5318-5
Printed in China

Published by Schiffer Publishing, Ltd.
4880 Lower Valley Road
Atglen, PA 19310
Phone: (610) 593-1777; Fax: (610) 593-2002
E-mail: Info@schifferbooks.com
Web: www.schifferbooks.com

For our complete selection of fine books on this and related subjects, please visit our website at www.schifferbooks.com. You may also write for a free catalog.

Schiffer Publishing's titles are available at special discounts for bulk purchases for sales promotions or premiums. Special editions, including personalized covers, corporate imprints, and excerpts, can be created in large quantities for special needs. For more information, contact the publisher.

We are always looking for people to write books on new and related subjects. If you have an idea for a book, please contact us at proposals@schifferbooks.com.

FRONT COVER: Henry Hall; *Princeton Tiger* pair, 1910, by Alexander Phimister Proctor; Holder Cloister; Nassau Hall. All sites at Princeton University.

BACK COVER: View of downtown Princeton through FitzRandolph Gate

TITLE PAGE: Pair of tigers, 1968, by Bruce Moore. Adams Mall, Princeton University

For Patrick, Niklas, and Natalie
—W. M.

For Sam, Emily, and Kate
—J. J.

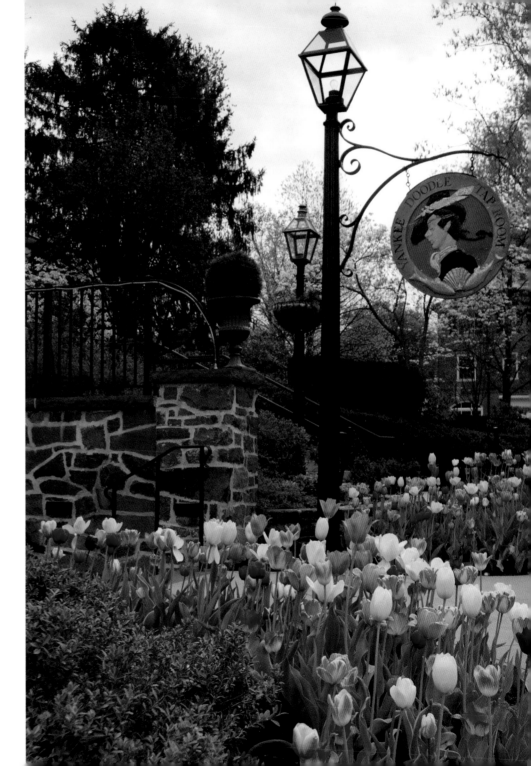

Sign of the Yankee Doodle Tap Room,
Nassau Inn, Princeton

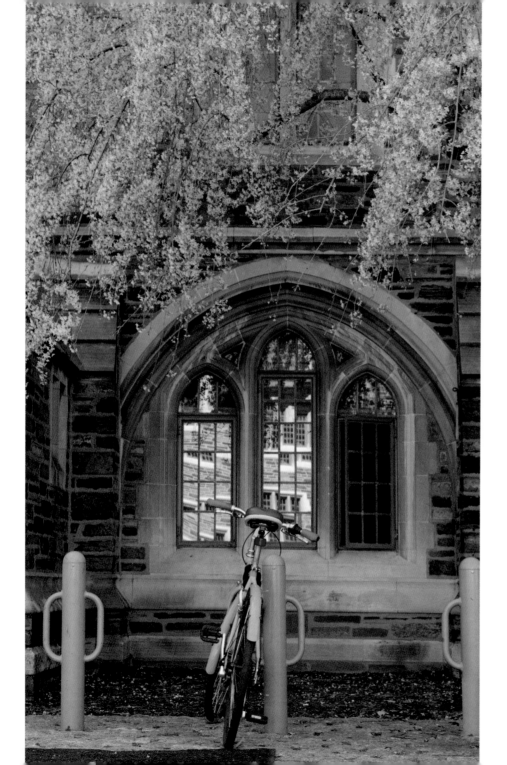

Henry Hall in spring, Princeton University

# Contents

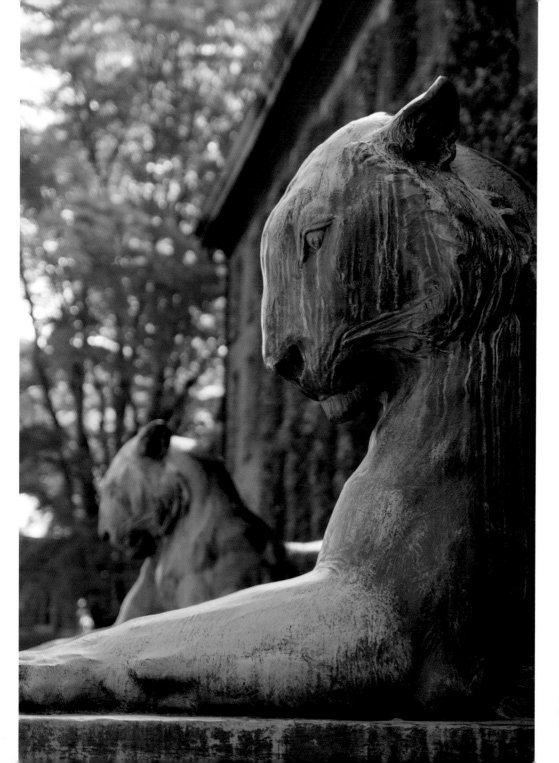

*Princeton Tiger* pair, 1910, bronze,
by Alexander Phimister Proctor,
sculptor, 1860–1950.
Nassau Hall, Princeton University

# Acknowledgments

This project—our first book—was made possible by the generosity of a great many people. We are very grateful to Laurel Cantor and Daniel Day of Princeton University for their interest, encouragement, and advice throughout the writing process. All of our community partners were tremendously supportive, especially Izzy Kasdin (Historical Society of Princeton), Jeff Nathanson (Arts Council of Princeton), and Barbara Webb and Elizabeth Allan (Morven). Kenneth Henke (Princeton Theological Seminary), Jon Hlafter (Princeton University), and Chris Ferrara (Institute for Advanced Study) carefully read our manuscript and provided valuable feedback.

Janet Hauge of the Princeton Public Library assured us continued access to the Princeton Room even through the library's second-floor renovation. We are also indebted to the Historical Society of Princeton as its journals and *Recollector* issues proved essential to our research.

Thank you, Rachel Benevento, for proofreading and editing.

To the artists, whose sculptures we show on these pages, and to their descendants: we deeply appreciate your permission to show these remarkable works of art.

It has been a great pleasure to work with Pete Schiffer, Catherine Mallette, Cheryl Weber, and the exceedingly competent staff at Schiffer Publishing: thank you for shepherding our guide to print!

Lastly, we wish to thank our families for accompanying us on this journey.

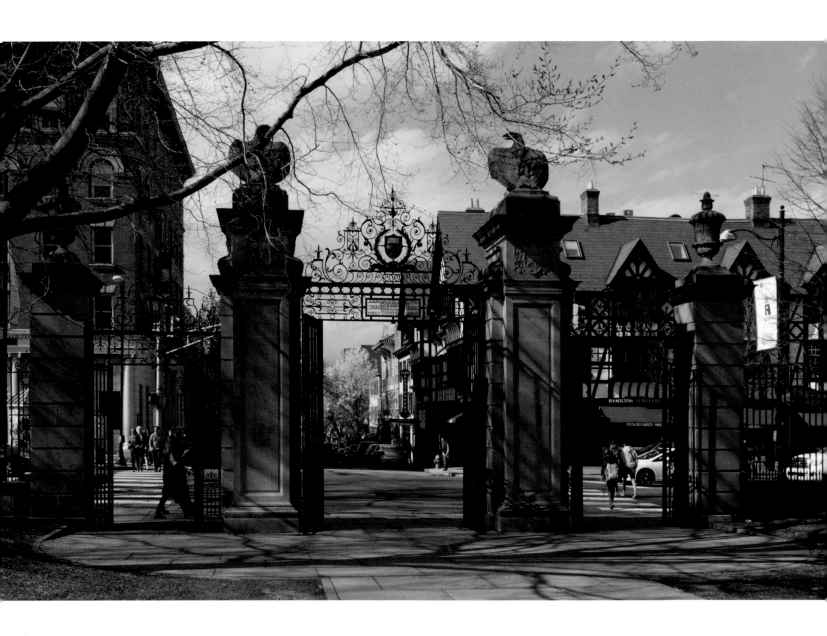

View of Princeton downtown through FitzRandolph Gate

# Introduction

What inspired us to write about Princeton? Much ink has been spilled about this idyllic college town. But surprisingly there are no guide books that cover both "town and gown" and offer an overview of the myriad attractions in the Princeton area. And so we joined up, a historian and a photographer, both residents, to create a photographic guide. This journey has compelled us to traverse Princeton, in every season and at every time of day, to take the many images included in this book. We hope they will spark your interest and imagination and encourage you to explore the town and its environs.

We set the stage with a history chapter, a relatively brief summary of the 300 years since the first Quakers bought land from William Penn and settled along the Stony Brook. We then invite you to experience Princeton yourself through five walking tours. Discover Princeton University's historic campus, well known and often photographed, as well as the more modern sections that feature the newest buildings and departments. Stroll through some of the town's historic neighborhoods. Meander along the Springdale Golf Course and explore not only the Graduate College but also Princeton Theological Seminary and the Institute for Advanced Study. Our captions offer small glimpses of the evolution of Princeton University, the history of the town, and the influential Stockton family. The captions also include helpful information for both guests and locals, such as tips on activities for kids, concert series, and annual events.

The last section of the book provides an overview of attractions within a one-hour drive of Princeton, not including New York City or Philadelphia. Our curated lists are structured by interest; a few attractions are described in detail.

So if you find yourself in this town—for a day, a week, a year—our guide will help you to discover and enjoy Princeton.

Historic bridge over the Stony Brook, near Quaker Road in Princeton

# A Brief History of Princeton

## THE BEGINNINGS

Standing in the shadow of FitzRandolph Gate at the intersection of Nassau and Witherspoon Streets today, it is hard to imagine that Princeton began as a sleepy backwater. Students from all over the United States and world pour through the gates each day, mixing with residents and tourists in Princeton's bustling historic downtown. While the architectural diversity and low skyscape give Princeton the feeling of a village, it is more like a large town in size and population—yet with the amenities of a much larger city. How did a colonial outpost in the New Jersey wilderness evolve into a worldly, cosmopolitan hub drawing generations of scholars, leaders, and entrepreneurs?

The answer starts with an ancient Native American trail. For centuries the Lenni Lenape people, also called the Delaware Indians, traversed what is now central New Jersey, shuttling between fishing grounds at the Delaware and Raritan Rivers. The Lenape's route, the Assunpink Trail, later came to be used by European settlers, the footpath giving way to a well-worn carriage road. First known as Old Post Road, it was later renamed the King's Highway, and Princeton's Nassau Street represents a segment of this historic thoroughfare. As this former Native American route became well-traveled, a significant number of Quakers found their way here, seeking land and religious toleration. Several families settled along the Stony Brook near the western edge of modern Princeton. One well-to-do member, Richard Stockton, bought one of the largest landholdings in colonial New Jersey from William Penn in 1701, setting the stage for his descendants to become one of Princeton's most prominent clans. This mostly Quaker community, which also included a number of slaves and freedmen, was generally referred to as "the settlement at Stony Brook" until approximately 1724 when the name "Prince-town" began to appear in local literature. Historians have speculated that the name may have paid homage to the defender of the Protestant faith, Prince William of the House of Orange-Nassau, later King William III of England; but the name is perhaps best understood within the context of nearby towns named during that same era: Kingston, Queenston, and Princessville.

Princeton's growth cannot be viewed apart from the Protestant Great Awakening, which swept through Europe and colonial America during the first half of the eighteenth century. The Great Awakening led to a schism within Presbyterianism between "Old Side" religious traditionalists and evangelical "New Side" believers who sought a more personal connection to God. New Side Presbyterians launched the College of New Jersey (renamed Princeton University in 1896), the fourth college in the colonies, in Newark in 1746. Although the school was intended as a seminary to train Presbyterian ministers, it was created through a charter by the colonial governor and founded as a non-sectarian liberal arts school. Students were

initially taught in private homes; eventually the trustees sought to establish a permanent site. Both Princeton and New Brunswick were considered as potential locations, but generous Quakers in Princeton—Nathaniel FitzRandolph, John Stockton, Thomas Leonard, and John Hornor—stole New Brunswick's thunder by donating land and money for the college. After the main building, a massive stone edifice christened Nassau Hall after King William III, was completed in 1756, the school moved in, and the stage was set for the town's future growth.

Even before the arrival of the college, Princeton had become a significant waystation along the King's Highway, which linked New York to Philadelphia. The latter trip took three days by stagecoach, and a number of inns and businesses began to spring up along Nassau Street to serve weary travelers. Only a few years after Nassau Hall and the president's residence rose up in what was becoming the village's heart, the school and town collaborated to establish the First Presbyterian Church (today Nassau Presbyterian Church), also on Nassau Street. The town center grew further as a handful of stately Georgian houses were built nearby, including the Bainbridge and Beatty houses.

In its early days in Princeton, the College of New Jersey faced considerable challenges, in part because five of its presidents, including notables such as Aaron Burr and the firebrand Jonathan Edwards, died in rather quick succession. The selection of the sixth president stirred up lingering tensions among Old Side and New Side Presbyterians, and so trustee Richard Stockton, son of John Stockton, set out to woo a neutral candidate, the esteemed Scottish Presbyterian minister John Witherspoon. Two years later, in 1768, Witherspoon agreed to helm the college. For the next twenty-six years this charismatic man would indelibly shape the school: raising funds, broadening the curriculum to include non-theological subjects, and adding faculty. As the college began to find its footing, the British Crown was becoming increasingly meddlesome in the colonies. Witherspoon became a passionate patriot and one of two local signers of the Declaration of Independence—the other being Richard Stockton— and the only clergyman to sign the declaration. Town and school became the center of Revolutionary War activity on January 3, 1777. On this night General George Washington marched his ragged troops into Princeton to launch a surprise attack on the British. The battle began at the western edge of town, then raged fiercely throughout Princeton and its surrounding area. Residences were plundered and many buildings damaged; Nassau Hall and the Church were "heaps of ruins," as Stockton's son-in-law Dr. Benjamin Rush reported (Wertenbaker 1946, 61). Yet the Patriots secured a much-needed

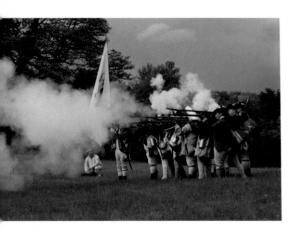

Living history military demonstrations at the Princeton Battlefield State Park

victory; indeed, the Battle of Princeton is often viewed as a turning point in the war. Princeton rose to prominence again several years later in 1783 when the Continental Congress fled a mutinous crowd in Philadelphia and sought a temporary home in Princeton. For the next five months Princeton served as the new nation's capitol, with congressional delegates hastily ensconced in taverns and private homes, including Richard Stockton's grand residence,

Morven. George Washington himself was headquartered at nearby Rockingham, a spacious farm owned by local gentry, the Berrien family.

Within a decade of the Revolutionary War's end, the new nation was wracked by sharp political debates as the Democratic Republican party emerged as an alternative to the Federalists. The French Revolution and its bloody aftermath further exacerbated these divisions. Princeton was not immune to the political tensions of the day, nor was the college, which had only just recovered from its wartime ravages. Now administrators were faced with new challenges: restive students began to chafe under the strict disciplinary standards, and a devastating fire in 1802 left only the walls of Nassau Hall standing. Trouble flared up again in 1807 when students rioted, and more than 120 students were suspended. Enrollment dropped after this incident; yet the college's leaders maintained their harsh policies, generating more unrest in subsequent years.

A time of great political ferment, the early nineteenth century was also a period of tremendous expansion. The western frontier was being pushed back and the nation's population was growing rapidly; as a result, the Presbyterian Church was confronted with a significant shortage of ministers. Church leaders decided the college's liberal arts education was no longer sufficient for the training of clergy; thus they founded the Princeton Theological Seminary in 1812 to provide a rigorous post-collegiate theological education.

## BECOMING PRINCETON

By the early nineteenth century, Princeton boasted two institutions of higher learning and might have remained primarily a college town, were it not for the lofty ambitions of Commodore Robert Field Stockton, scion of the prominent Stockton family. He became one of the chief investors in the Delaware and Raritan (D&R) Canal, which, along with several other canals of that era, promised to revolutionize the transport of goods. Completed in 1834, the canal brought a surge of laborers, mostly from Ireland, and new business to Princeton. A few years later, the Camden and Amboy Railroad was installed on the banks of the canal, offering fast service to New York and Philadelphia. A little community called the Basin thrived at the turning basin and wharves at the bottom of Canal Street (today Alexander Street). The town of Princeton expanded as new streets were laid out and homes constructed, many by local architect-builder Charles Steadman, who soon became a pillar of the community.

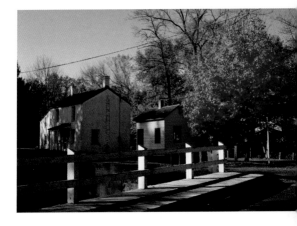

Locktender's house at the Delaware and Raritan Canal, Kingston

Meanwhile the college was still an institution led mainly by Presbyterian ministers, but it slowly broadened its science program, and alumni began to play a larger role in shaping the school. President John Maclean Jr. was instrumental in launching this transformation: raising funds, founding the alumni association, and luring stellar faculty such as scientist Joseph Henry. Maclean's vision and steady hand enabled the college to overcome the difficulties of the past decades, flourish once again, and survive fresh challenges such as

the second destruction of Nassau Hall by fire in 1855 and the Civil War. Another Scottish import, the Reverend James McCosh, succeeded Maclean as president in 1868 and shepherded the school through the difficult postwar period. A highly effective leader and successful fundraiser, McCosh vastly expanded the curriculum and campus. He also introduced the first graduate degree programs and dreamed of seeing "me college," as he called it, become a university (Oberdorfer 1995, 74). It was only after his death, however, at the school's sesquicentennial celebration in 1896, that Princeton would officially be renamed.

The gradual introduction of scientific subjects such as geology and astronomy into the college's curriculum presented problems for the school, given its deep religious roots. McCosh, who openly accepted the theory of evolution, tried to reconcile science and religion; however, an increasing secularization was unavoidable. As the influence of the church diminished, the role of the alumni, who had become very involved in funding the school, grew. No alumnus from this era was more powerful than Moses Taylor Pyne. A graduate of the Class of 1877, Pyne was named a trustee at the age of twenty-eight. He went on to serve as trustee for thirty-six consecutive years and became one of the school's most important benefactors, organizing the alumni, funding many buildings, and covering gaps when the school ran a deficit. A passionate fan of the Collegiate Gothic style, he was instrumental in the university's decision to start building exclusively in the style of Oxford and Cambridge Universities.

Pyne purchased the stately Greek Revival mansion "Drumthwacket" for his home (today the official residence of the governor of New Jersey), putting him in the vanguard of an elite

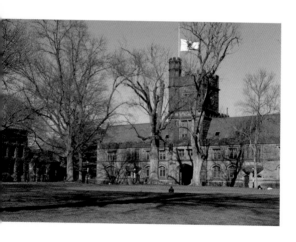

East Pyne Hall, Princeton University. Donated by Moses Taylor Pyne's mother, Mrs. Percy Rivington Pyne

newly arriving in Princeton. The town not only offered an alluring country setting but also train service to New York and Philadelphia and, eventually, a trolley line to the busy nearby city of Trenton. Several other families bought old estates, settling in villas in the far west. Closer to town, grand new homes sprang up on former Stockton lands. As Princeton gained popularity and the university went on a building spree, the town expanded. The vibrant African American community flourished and the first of several waves of Italian immigrants arrived. Sought after as stonemasons and quarriers, Italians also helped dig Princeton's new lake, a gift from the philanthropist Andrew Carnegie.

Although Princeton officially became a university in 1896, it took several decades to transform the college into a university. It was Woodrow Wilson who firmly set Princeton on this path. When Wilson took the reins in 1902, the student body was larger than ever; but academic standards had lapsed, and the elite eating clubs—a unique Princeton tradition—dominated the school's social scene. Even as a professor Wilson had imagined reforming all major aspects of the school, so as president he set to work immediately, raising teaching standards and reorganizing the faculty. He also reconfigured the curriculum by introducing the modern concepts of general studies for freshmen and sophomores and a major for juniors and seniors. Wilson inaugurated the preceptorial system and hired a slew of new faculty to facilitate small group work. When he forged ahead,

intent on similarly revolutionizing campus life, and attempted to abolish the eating clubs, he was thwarted, having failed to gain the support of the alumni. After losing a subsequent battle against Dean Andrew Fleming West over the location of a new residential complex for graduate students, Wilson soon turned to state, then national politics.

Thanks to Wilson's successful reforms, Princeton's star—especially that of the relatively new Graduate School—rose swiftly. Striving to attract the best possible faculty, Wilson had persuaded the board to reaffirm that traditionally Presbyterian Princeton was a non-sectarian institution and hired the first Jewish and Catholic professors. Of course, the student body was still almost exclusively made up of Anglo-Saxon, Protestant men; in fact, Wilson was actively discouraging Jews and African Americans from applying, arguing they would not fit into "the whole temper and tradition of the place" (Axtell 2006, 7–8). It was only much later, after World War II, that the student body would slowly become more diverse.

Wilson also adamantly opposed coeducation, yet women had long played an important role at the school. Women, both black and white, served as cooks and laundresses, liberating students and faculty from domestic tasks. Sisters, daughters, mothers, wives, and widows of alumni generously funded grand buildings and endowed chairs and scholarships. Likely no woman was as influential as Isabella McCosh, wife of President James McCosh. She became a surrogate mother to many students, ministering to the sick both on campus and in town for over two decades, and lobbied for a proper infirmary. The McCosh Infirmary was built in 1892, and a decade later the Ladies' Auxiliary to the Infirmary was established. Faculty wives founded another influential women's service organization in the early twentieth century, the University League, which launched several initiatives including a job roster, art museum docent program, and child-care center. Gradually women began to assume clerical roles and, later, research and instructional positions at the university.

In the 1930s the Great Depression descended on both town and school; many residents lost their jobs, and students increasingly sought employment to offset their expenses. Shortly before the 1929 stock market crash, a local redevelopment project to establish a picturesque village-style town center, now known as Palmer Square, had been unveiled. Calling for the relocation of families and businesses and the demolition of an entire neighborhood, the plan generated much controversy. When construction got underway in 1936, however, the project helped Princeton overcome the Depression, according to historians.

View of Palmer Square, Princeton

One university-led project completed just before the crash became a vital part of both town and school. The McCarter Theatre was originally designed as a stage for the cherished Princeton Triangle Club, which produced a wildly popular, original musical comedy each year. The theater soon boosted the arts in Princeton as it became a venue for touring and pre-Broadway shows, attracting first-rate performers including Princeton's own native son Paul Robeson, the great singer, actor, and human rights activist.

Other buildings constructed at the university during the Depression included new homes for the chemistry and mathematics departments, reflecting a major shift in focus within the university and larger scholarly community. Princeton's stellar science faculty, assembled over the prior two decades, cemented the school's reputation as an exciting place for science and mathematics research. The year 1933 represented a watershed as it marked the arrival in Princeton of the world's most famous scientist, Albert Einstein. Einstein became one of the first professors at the newly founded research center, the Institute for Advanced Study (IAS). As Einstein and IAS began helping scholars to escape Nazi Germany, Princeton soon replaced Göttingen, Germany, as an international mecca for mathematics.

When World War II broke out, Princeton's civilian students—along with town residents—began to enlist. At the same time, enrollment in the now-renowned science departments at the Graduate School soared, and students and professors began working on a host of war-related government projects. Both university and IAS scholars made major contributions during the war ranging from the identification of cultural monuments in Germany to work on the Manhattan Project.

## MODERN TIMES

In the decades after World War II Princeton experienced tremendous change. Key improvements in transportation, developing local industries, and emergent communication technologies made the town ever more accessible and desirable, sparking rapid population growth. The university also made foresighted decisions to expand and build partnerships with outside entities, both private corporations and the government. While the town undoubtedly benefited from these innovations and new arrivals, there were also repeated calls for smart growth, retaining Princeton as an independent community, and keeping Princeton *Princeton*.

Billy Johnson
Mountain Lakes
Nature Preserve

The area's evolution into a thriving economic hub arguably began in 1915 when the Manhattan-based Rockefeller Institute for Medical Research established a branch on the far side of Lake Carnegie, in Plainsboro. The university worked closely with Rockefeller officials from the start, setting the stage for future collaborations with private industry. The rising popularity of automobile travel in these early decades propelled the improvement of roads and highways along the eastern corridor, facilitating travel to and from Princeton. The process of suburbanization gained momentum after commuter train service to New York's Penn Station was established in the 1930s. New businesses settled in the area, and the university opened the James Forrestal Research Center as a site for most of its defense-related research in 1951. That same year construction began on the New Jersey Turnpike, and seemingly overnight an entire system of highways traversing New Jersey was installed. The transformation continued in 1973 when the university expanded its Forrestal Campus and launched an

office-research park, the first step in the decades-long development of the so-called Princeton Corridor along US Route 1.

As Princeton's population swelled, significant parts of the township—until then mainly farmland—were converted into housing tracts to accommodate the influx of new residents. At the same time, anxiety about loss of open space increased. By the early 1960s, when almost half of the township had been developed, town planners started working to protect Princeton's integrity as a town and to preserve some of the remaining green space for recreation and conservation. Great progress has been made in the decades since, as parks have been created all around Princeton, including the Mountain Lakes Open Space Area and the park all along the D&R Canal, to name just two. Organizations like Friends of Princeton Open Space and the D&R Greenway Land Trust strive to preserve a contiguous system of greenways in the greater area. As the amount of available land in Princeton dwindles, the question of whether and how to develop the remaining bits continues to be ardently debated.

The steady stream of newcomers over the last century, combined with the effects of the civil rights movement, have gradually transformed Princeton into a more diverse, international, and integrated community. A segregated town until well into the middle of the twentieth century, Princeton took an important step towards greater racial equality in 1947, after the passage of anti-discrimination laws in New Jersey. These laws spurred the implementation of the Princeton Plan, a reorganization and desegregation of the Princeton public schools. Further progress was made when the first African American officials were elected to the school board, town and borough councils, and as mayor in the 1960s and 1970s. In the 1980s and the decades that followed, diversity in Princeton increased significantly as the town began to witness an influx of new residents from Latin America, then Asia. The university, IAS, and numerous local companies with transnational and sometimes transient workforces have continued to add to the mix. Today students in Princeton's public schools reportedly speak over fifty different foreign languages at home, a clear reflection of the town's diversity.

The Jewish Center, Princeton

Religious diversity concomitantly increased in Princeton during the second half of the twentieth century. The small but longstanding Jewish population thrived in the postwar era, chartering a synagogue, the Jewish Center, in 1947, and constructing a permanent home on Nassau Street in 1958. The arrival of visitors and residents from all over the world has brought an attendant variety of religious traditions, and today there is a place of worship for almost every religion or denomination in the Princeton area.

The university has similarly been transformed. After World War II, admissions rose as President Harold Dodds sought to accommodate the growing number of veterans who were returning to begin or finish their educations. Diversity on campus increased slowly as greater numbers of Jewish students enrolled, and Princeton launched a scholarship

program. In the early 1940s, students and faculty had started calling for the admission of African American undergraduates to the school. But it was only in the 1960s that the university responded to the tremendous social and cultural upheaval occurring throughout the United States and beyond. Under the leadership of President Robert Goheen, a new initiative to admit more minority students was launched in 1963, and within several years the number of African American students had grown significantly. In 1969, the university introduced coeducation. As the student body became rapidly diversified, the escalation of the Vietnam War and shocking Kent State killings generated political protests and, eventually, productive dialogues between students, faculty, and the administration.

Today, Princeton University's student body is vastly different than it was a hundred years ago. The numbers of men and women in each class are typically equal, the vaunted eating clubs are coed, and many religions are practiced on campus. Nearly one quarter of the Class of 2019 is Asian American, fourteen percent are international students, eleven percent are Latino, and seven percent are African American. Need-blind admissions ensure that significant numbers of students from less affluent backgrounds are able to attend, and the university has devoted much energy to making Princeton inclusive of and responsive to all of its members.

Campus life has also been thoroughly reimagined. As enrollment gradually increased through the twentieth century, the university sought to relieve overcrowding in dormitories and its dining hall and to increase a sense of community. In the early 1980s a set of two-year residential colleges was established where freshmen and sophomores would live, eat, and study together. Four-year residential colleges, which for the first time included juniors and seniors, were introduced in 2007 after the decision was made to increase the student body by 500 undergraduates.

The curriculum has also continued to evolve in response to a changing world. During World War II government-funded research became a boon to the school's science and engineering programs and remained an important factor well into the 1960s. The university's Forrestal Center still houses the Princeton Plasma Physics Laboratory, which, in collaboration with the Department of Energy, explores fusion as an energy source. Over the last decade the school has dedicated significant resources to emerging fields such as integrative genomics and neuroscience and built critical research and study facilities, including the Frick Chemistry Laboratory and the Peter B. Lewis Library. The humanities and social science programs have also been transformed over time, as various subjects have grown or diminished in importance. To name only one of the many changes over the last decades, in 2015 the board of trustees approved a new major in African American Studies, elevating the Center of African American Studies to department status.

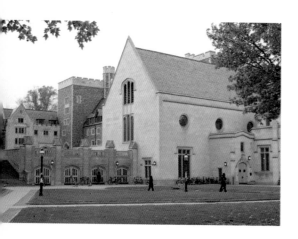

Whitman College,
Princeton University

In 2014, Christopher Eisgruber, Princeton's twentieth president, launched a strategic planning process; two years later, the resulting report reaffirmed the school's belief in the concept of liberal arts education. Even as the value and affordability of this type of degree

are being fiercely debated, and as technology dramatically rewrites how and what we learn, the university has recommitted itself to residential liberal arts education, scholarly research, and its time-honored mission to serve others. This mission extends to all of "humanity," in the words of Supreme Court Justice Sonia Sotomayor, Class of 1976, who amplified Princeton's informal motto in 2014 (*Princeton Alumni Weekly* [*PAW*], March 19, 2014). To this end the school will expand its undergraduate student body by another 500 students, which will allow it to increase socioeconomic diversity, and plans to focus on the Graduate School to fulfill critical teaching and research goals. In an indication of further transformations on campus—which may well impact the greater Princeton area—the university has acknowledged the need to invest heavily in fields such as information technology and engineering. Princeton also aims to "develop a more robust innovation ecosystem," as President Eisgruber put it, by collaborating with outside partners (*PAW*, March 2, 2016).

## CONCLUSION

In 300 years Princeton has been transformed from a tiny Quaker hamlet along the Stony Brook into a town of 30,000 residents, graced by several famed educational institutions. The much larger Princeton region encompasses all of Mercer County and parts of Somerset and Middlesex Counties, and is home to about 400,000 residents. A host of corporations, particularly financial and pharmaceutical companies, are headquartered in the area, which is also a major tourist hub, drawing two million visitors annually.

So how did Princeton become what it is today: a picturesque village surrounded by farms and forest, a suburb to Philadelphia and New York, but also a magnet in its own right? As we have suggested, one key contributing factor to Princeton's founding and growth has been its location on a major transportation corridor between New York and Philadelphia—the King's Highway in colonial times, later the canal and Camden and Amboy Railroad, and finally, US 1 and Interstate 95. The second critical factor has surely been Princeton University. The school has played a pivotal role over the centuries: building and expanding, attracting other educational institutions and corporations, drawing new residents to the town. Yet looking more closely at the history, it has, of course, been the people who have made this town and region what they are today. Four forward-thinking Quakers succeeded in attracting the fledgling Presbyterian college to Princeton. Prescient university presidents, generous trustees, savvy entrepreneurs, and a long line of innovators followed, shaping the school, town, and region. But today's Princeton would not have evolved, had it not been for the countless ordinary Princetonians, residents, and town leaders who have championed smart growth, protected open space, and fought to preserve Princeton's character, which is, in the end, what draws many of us here.

We invite you to join us as we traverse town and campus on the forthcoming five walks and discover Princeton for yourself. On the way we will travel through time from the colonial era to the present and hint at some of the stories that led Princeton to become what it is today. But don't stop there: meander further through some of the other neighborhoods of this town, many of which still hearken back to times past.

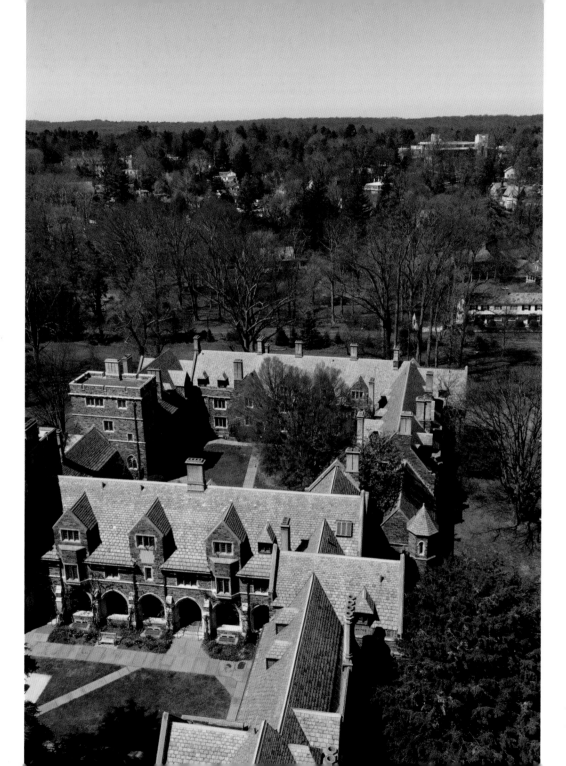

View from Cleveland Tower, Graduate
College, Princeton University

# Out and About in Princeton

Princeton's centuries-long history is all around us, and as we wander along Victorian-era alleys, under arches, and down shady streets lined with elegant white clapboard houses, we will catch glimpses of the past. While it is impossible in this book to cover all of the parts worth exploring, we have designed five walks that highlight some of the most iconic, historic, and interesting areas of town. On the way we will suggest a few ways to extend the walks and roam a little further.

WALK ONE: Historic University

WALK TWO: Downtown Princeton

WALK THREE: West Around Mercer Hill

WALK FOUR: The University in the Twenty-First Century

WALK FIVE: From Seminary to Institute

These walks feature some of the town's most well-known attractions, but the greater Princeton area includes many more interesting and unique sites. The last section of the book provides a useful overview of notable area attractions.

# WALK ONE: Historic University

On this walk we will traverse the oldest part of the campus, pausing at many of Princeton University's most recognizable and well-loved buildings, and travel through nearly two centuries of history, from the school's founding through World War II.

1. FitzRandolph Gate
2. Nassau Hall
3. Maclean House
4. Joseph Henry House
5. West College
6. Cannon Green
7. Whig and Clio Halls
8. Chancellor Green
9. East Pyne Hall
10. McCosh Hall
11. University Chapel
12. Firestone Library
13. Princeton University Art Museum
14. Prospect House and Garden
15. Alexander Hall
16. Blair Hall and Tower
17. Campbell Hall
18. Holder Hall and Tower
19. Madison Hall

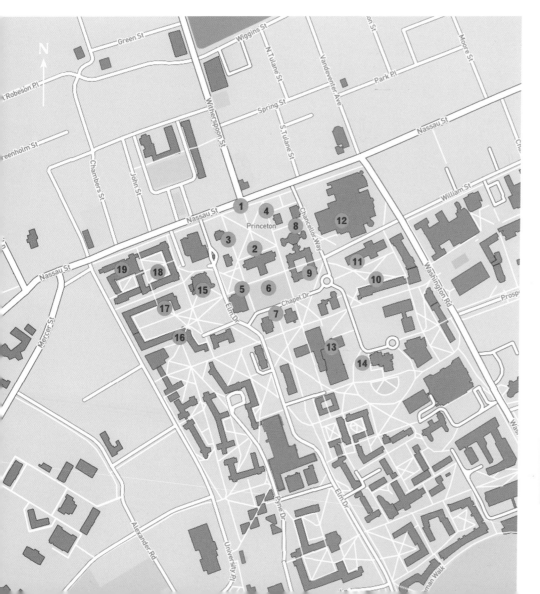

Families may want to consider combining their walking tour with one of the programs the university offers regularly for children of all ages. Check the website of the Office of Community and Regional Affairs for details on youth programs.

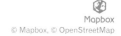

Mapbox
© Mapbox, © OpenStreetMap

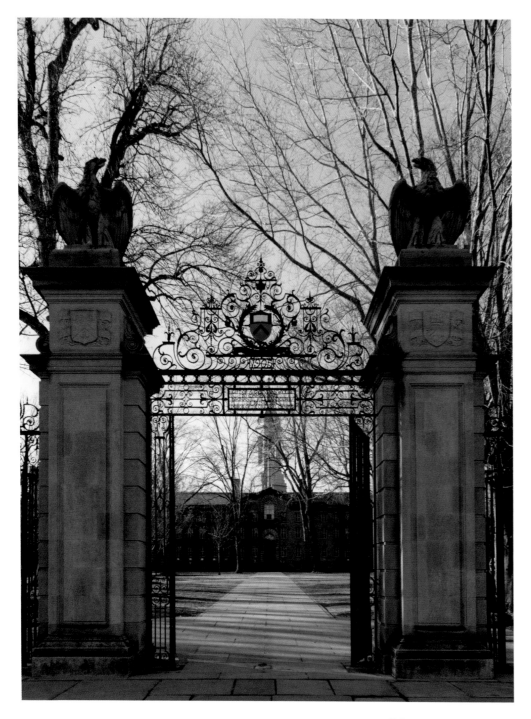

## FitzRandolph Gate

We begin at the most recognizable and iconic entrance to the campus: FitzRandolph Gate. This imposing structure, with its filigreed ironwork and pair of stone eagles, fronts Nassau Street and was erected in 1905 in honor of Nathaniel FitzRandolph, one of the early donors of land and money for the College of New Jersey, now Princeton University.

For many years FitzRandolph Gate was firmly closed; it was only opened for commencement celebrations and certain very important dignitaries like the Crown Prince of Sweden. In 1970, after a tumultuous period of political activism, the Class of 1970 requested the permanent opening of the gate, symbolically opening the university to the town and the world beyond. The class motto, "Together for the Community," is inscribed on the gate's eastern pillar along with a peace symbol in the final digit of "1970." In recent years a campus tradition has evolved prompting students to exit through the side gates rather than the main gate for fear of jinxing their eventual graduation.

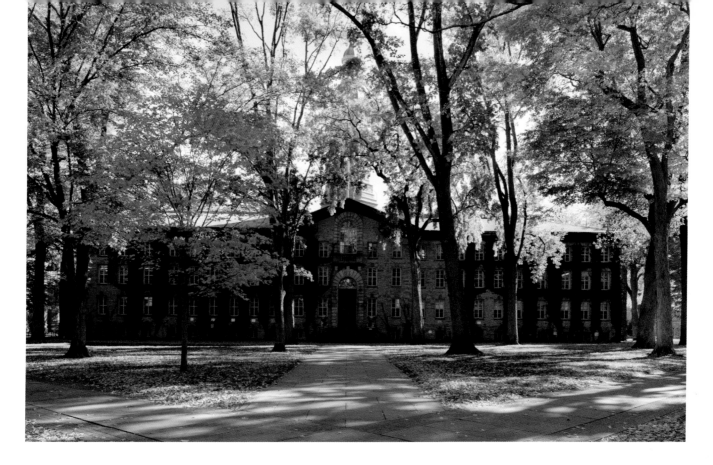

Nassau Hall

Nassau Hall constitutes the symbolic center of the campus. This ivy-clad building, completed in 1756, was the first structure built when the College of New Jersey moved from Newark to Princeton. The original Nassau Hall was a Georgian-style edifice designed by the highly regarded carpenter-architect Robert Smith. Hailed as the largest building in the thirteen colonies, Nassau Hall encompassed all aspects of college life: classrooms, dining hall, dormitory, library, and a two-story prayer hall. The original walls were built with locally quarried stone to a thickness of more than two feet and withstood the American Revolution, student riots, and two fires. After the second fire in 1855, renowned architect John Notman restored and rebuilt Nassau Hall in the then-popular Italianate style, preserving the original walls, adding the tall campanile, and fireproofing the structure through the extensive use of iron beams. Today Nassau Hall contains high-level administrative offices. The former prayer hall, long since expanded and rebuilt, is still considered the most sacred interior space and features several significant portraits. It is used for faculty and trustees' meetings but remains off limits to the public.

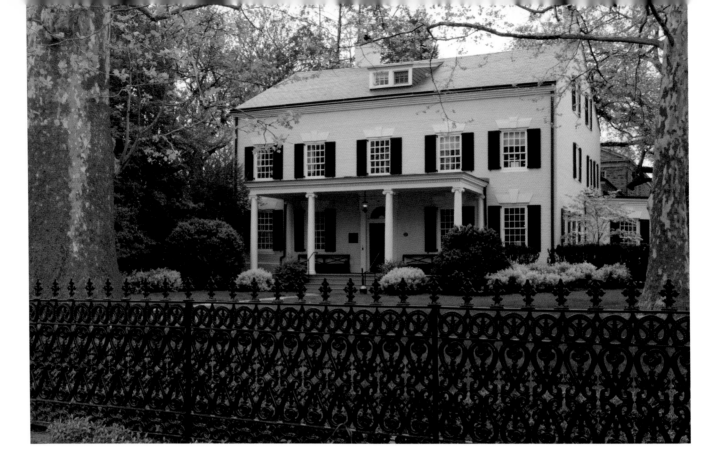

Maclean House

Originally the residence of Princeton's early presidents, Maclean House was designed and built by Robert Smith and represents one of the finest examples of Georgian-style architecture in Princeton. The first leader to live here for a significant length of time was John Witherspoon. At the helm of the school from 1768 until his death in 1794, he was not only an influential teacher and president, but also a church leader and statesman, serving in congress for six years.

Today Maclean House is the home of the alumni council, the governing body of the alumni association. This thriving organization, which counts more than 90,000 members to date, was founded in 1826 by John Maclean Jr. to help save the college. When Maclean took the reins as vice president in 1829, the school was on the verge of closing: years of riotous student protests over strict discipline and a resulting decline in enrollment had taken their toll. With the help of alumni, Maclean produced a turnaround and went on to lead the school for almost forty years, first as vice president and later as president.

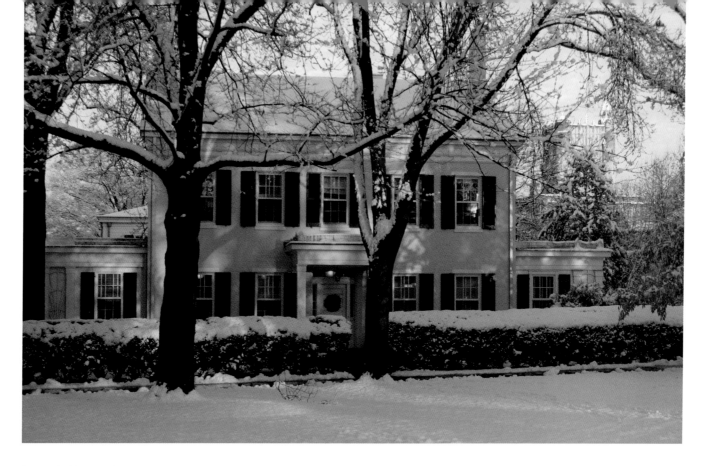

Joseph Henry House

This graceful yellow house was built for Professor Joseph Henry, one of America's leading scientists at the time. He is best known for his contributions in the field of electromagnetism, where he discovered electrical self-inductance; fittingly, the unit of inductance is called "Henry." Henry was hired by John Maclean Jr. in 1832 and taught not only physics but also courses on geology, astronomy, and architecture. He was a beloved teacher who often integrated experiments into his classes, which was unusual at a time when professors tended to lecture and pupils recite. On one occasion Henry tested a large magnet of his own design lifting 3,500 pounds—including eight students! Other tales tell of his experiments in the field of telegraphy where he ran wires between his laboratory and his house so he could notify his wife when he would be ready for lunch. Henry's magnet can be seen on the first floor of the physics building, Jadwin Hall.

The Joseph Henry House is one of Princeton's famous "moved houses" and finally arrived at its present position on the front campus after three relocations.

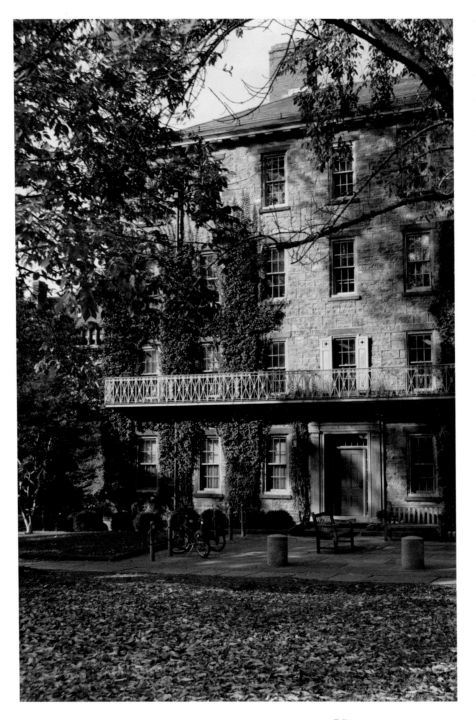

## West College

By the early 1830s the tide had begun to turn at the college, thanks to a bold plan by John Maclean Jr. to increase the faculty and recruit a number of noted new professors. As enrollment increased, Nassau Hall grew overcrowded, necessitating separate housing for students. East College became the first dormitory, quickly followed in 1836 by West College (pictured), facing it across the Cannon Green.

Back then the campus was laid out symmetrically: Nassau Hall, also called Old North, was flanked by East and West Colleges and stood across from Whig and Clio Hall. On the front campus, Stanhope Hall faced Philosophical Hall. Over time, however, the symmetry was lost as new construction led to the razing of old buildings. Philosophical Hall was torn down to make way for Chancellor Green Library. And two decades later, East College was destroyed to make way for Pyne Library, an act called the "Crime of 1896" by outraged alumni, who had spent happy years in East College.

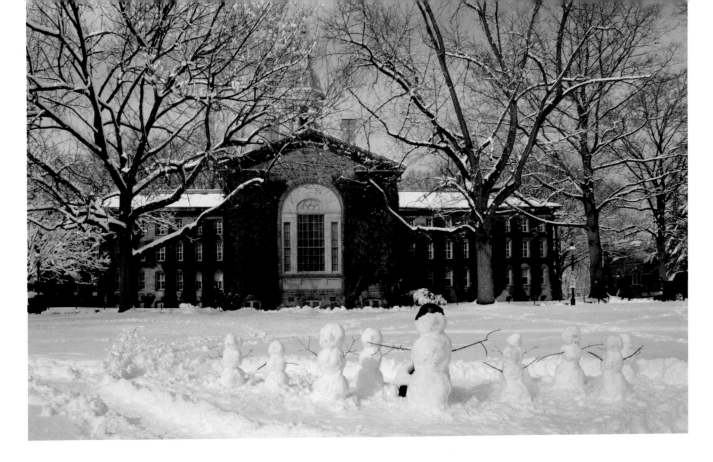

## Cannon Green

In the early nineteenth century, before the advent of athletics, students played a game of shinny (a precursor of hockey) here on the green behind Nassau Hall. Their teachers were shocked; exercise was considered both ungentlemanly and unhealthy. The space is now called Cannon Green after the Big Cannon buried muzzle down (and seen behind the center snowman), which supposedly dates to the Battle of Princeton. The Little Cannon lies between Whig and Clio Halls.

The green has certainly seen its share of history, having served as a locus for student activities, celebrations, and historic rivalries. Traditionally, even today, great bonfires are held here whenever the Princeton Tigers beat both Harvard and Yale. After a particularly successful season in 1933 the bonfire is said to have flamed higher than Nassau Hall!

## Whig and Clio Halls

These Greek temples housed the American Whig and Cliosophic societies, a pair of debating societies dating to the 1760s. For about 100 years they were at the center of the students' extracurricular lives, but their importance diminished as sports teams and eating clubs were founded. Now merged, "Whig-Clio" remains active, sponsoring debates, mock trials, and lectures.

On Adams Mall, between Whig and Clio Halls, stands a set of tigers, a highly visible symbol of the university. This pair of tigers, created by Bruce Moore, represents a female and a male and was coincidentally installed in 1969, the year Princeton launched coeducation and first opened its doors to female undergraduates.

A century before coeducation was introduced, the poet Annis Boudinot Stockton became the first and only female on Whig's member lists, having been retroactively recognized for rescuing the secret society's documents and treasures on the eve of the British invasion of Princeton. A self-described passionate citizen of the new republic, Stockton wrote, "Tho a female I was born a patriot" (Greiff 2004, 40).

Chancellor Green

No school would be complete without a library, but when President James McCosh took over in 1868 he was shocked to learn that the library was open only once weekly for an hour or two. He immediately hired the first full-time librarian, increased hours, and raised funds both to expand the collection and construct this polychromatic, octagonal building known as Chancellor Green Library. Designed by William Appleton Potter and completed in 1873, this acclaimed example of High Victorian Gothic boasted space for an astonishing 80,000 books. Yet within a decade the collection had already outgrown its new home. Today the octagon houses a reading library and study space for the Andlinger Center for the Humanities, in addition to a basement café that serves as a refuge for students and visitors alike.

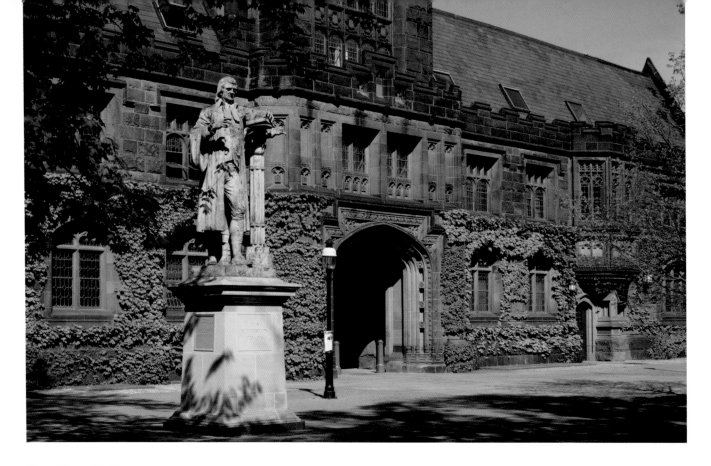

East Pyne Hall

The year 1896 marked a major milestone, Princeton's 150th anniversary or sesquicentennial. Future dean of the Graduate School Andrew Fleming West organized elaborate festivities lasting several days, including lectures by scholars from all over the world, a torchlight procession through town, and an address by President Grover Cleveland. On this occasion McCosh's dream finally came true, and the college proclaimed that it would henceforth be known as Princeton University. The new university announced expansive building plans that included a dormitory (Blair Hall) and a new library (now East Pyne Hall). Once completed in 1897, the state-of-the-art library, together with Chancellor Green, which became a reading and reference room, possessed a capacity of 1.2 million books.

  Both West and major donor and trustee Moses Taylor Pyne were fervent admirers of medieval Oxford and Cambridge. They were instrumental in starting Princeton's Collegiate Gothic love affair, which began with Pyne Library and lasted until well into the 1940s.

*John Witherspoon (1723–1794)*, 2001, by Alexander Stoddart. East Pyne Hall, Princeton University

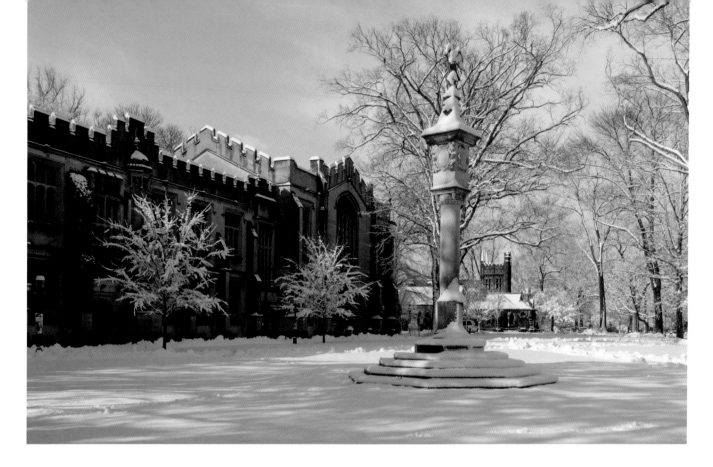

McCosh Hall

During President Francis Landey Patton's tenure at the end of the nineteenth century Princeton's student body and faculty more than doubled, and a dozen new buildings were constructed. At the same time, academic standards had grown lax, and students had become lazy. When Woodrow Wilson became university president he immediately tackled these issues. He hired young professors, increasing the faculty by fifty percent, and introduced the so-called preceptorial system, still in place today. His system, based on English tutorial systems, allowed students to study in small discussion groups called precepts.

McCosh Hall was completed in 1907 and played a critical role in the implementation of the new system by providing much-needed classroom space. Another example of the Collegiate Gothic style, the building also features some fun, modern details, like the grotesque "football runner" dashing to the goal line above the western doorway.

The *Mather Sun Dial*, in the foreground of the image, is a replica of a sixteenth-century sundial at Oxford University. For many years tradition dictated that only seniors were permitted to sit at its base.

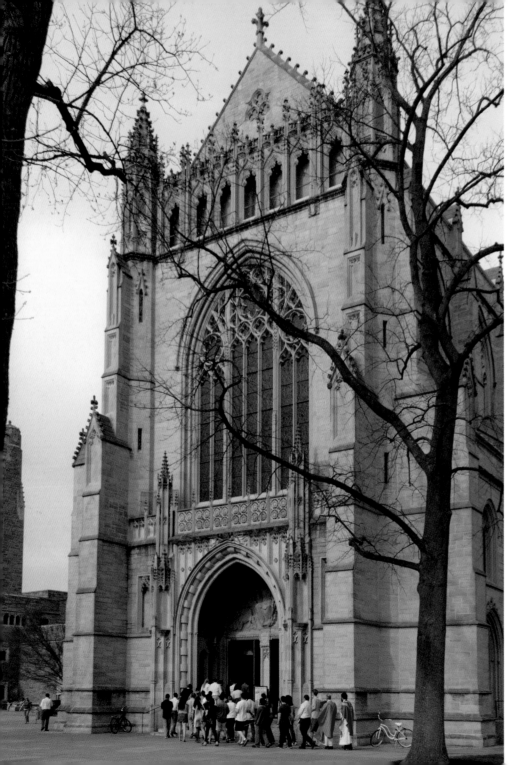

## University Chapel

Princeton University had begun as a training ground for Presbyterian ministers, and although the university's curriculum began to broaden rather swiftly, the Presbyterian church wielded a large influence until the end of the nineteenth century. It was only in 1902 that the first layman, Woodrow Wilson, became president. Consequently, chapel attendance—originally twice daily—remained mandatory for a long time. This requirement was lifted very slowly, despite increasing student complaints, and only ended when compulsory Sunday service for freshmen was finally abolished in 1964.

When the school's chapel burned down in 1920, President John Grier Hibben rose to the challenge. He quickly made plans to construct a spectacular new place for worship that would dazzle and inspire students and ward off the threat of growing secularism. Ralph Adams Cram, university architect and expert on the Collegiate Gothic, received the commission. By 1928 one of the largest university chapels in the world was finally completed, a stunning edifice with a soaring ceiling, huge stained glass windows, and a wealth of wood and stone carvings.

Today the multidenominational chapel hosts a variety of religious and ecumenical services as well as many events and concerts open to the public.

## Firestone Library

Although Pyne Library soon became overcrowded, first the Great Depression and then World War II prevented the construction of a new library. Anticipated building costs escalated as the years went by. Finally, in 1948, a multitude of alumni and friends of the university came together and donated the funds, and at last Firestone Library was completed. It was controversial, as the pared-down Gothic did not satisfy traditionalists and was considered a sham by modernists. However, the modern open-stack library proved revolutionary and provided a boost to Princeton. Firestone offered not only sufficient space for books, but also space for studying and thesis work. Over the years it has become a crucial resource for students and scholars, amassing a peerless collection in part through many generous gifts. To name just one example, the Scheide Library, donated by philanthropist William Scheide, Class of 1936, includes invaluable pre-Luther Bible editions.

The Department of Rare Books and Special Collections regularly exhibits materials from its collections, and the charming Cotsen Children's Library offers programs for children of all ages.

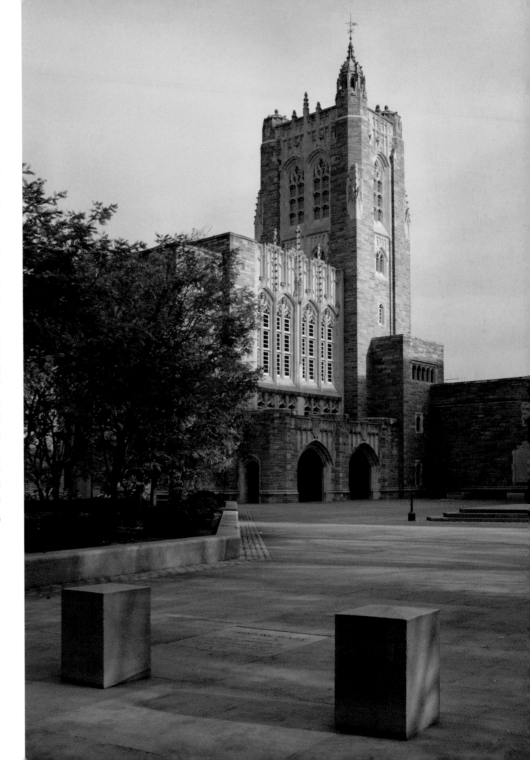

Princeton University Art Museum

President James McCosh was convinced that "Fine Arts should have a place, along with Literature, Philosophy and Science, in every advanced College" (Axtell 2006, 488); in 1882 the college committed to this emerging discipline by establishing a history of art program. Concurrently, the art museum was founded as an object-based teaching museum. As a result of generous donations over the years by both its leaders and many alumni, the museum now owns more than 92,000 objects, which cover the spectrum from ancient to contemporary art. Due to a dearth of space, only a fraction of the collection is on exhibit at any given time.

The museum is a dynamic place, featuring changing exhibitions, regular docent tours, scholarly lectures, family-friendly programs—even yoga.

Right across from the museum is Murray-Dodge Hall, home of the student Theatre Intime and the Princeton Summer Theater, both of which offer public performances.

## Campus Art

The impressive collection of twentieth- and twenty-first century sculptures, displayed throughout campus, was established thanks to an anonymous donor. The John B. Putnam Jr. Memorial Collection was named after a member of the Class of 1945 who died in World War II. The first set of twenty sculptures was installed in 1969–'70 and includes such favorites as Jacques Lipchitz' *Song of the Vowels* in front of Firestone Library and Henry Moore's *Oval with Points* between Stanhope Hall and West College.

The collection continues to expand; in 2015 a new work of art was permanently installed in front of the art museum. *(Any) Body Oddly Propped* by brothers Doug and Mike Starn is constructed of six glass panels supported by bronze tree limbs.

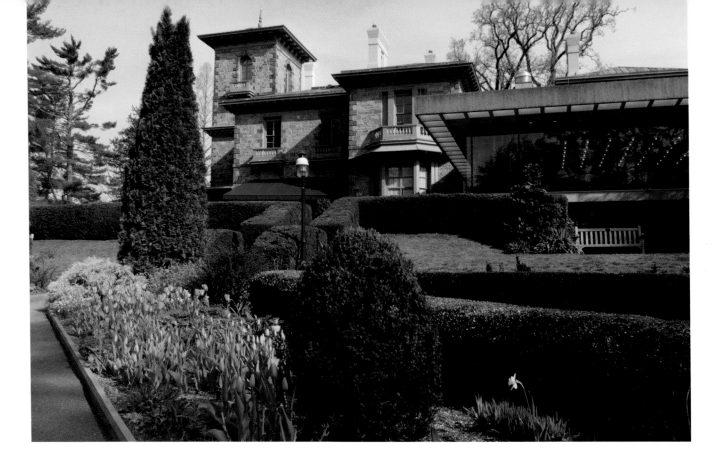

Prospect House and Garden

From the back of Prospect House one can see that the house sits on a small hill and thus appreciate that it was originally named for its "prospect" or wide views over fields and orchards, now long gone. Architect John Notman designed Prospect House in its current form when the Italianate style was all the rage in the middle of the nineteenth century. At that same time the landscaping was laid out with an English-style lawn in the front and a flower garden in the back.

The house became the president's house in 1878; McCosh, the first president to live here, thought it was the best in the world. The flower garden in the rear was remodeled by Woodrow Wilson's wife Ellen Axson Wilson, who as First Lady went on to design the Rose Garden at the White House. Today Prospect House serves as a faculty and staff club.

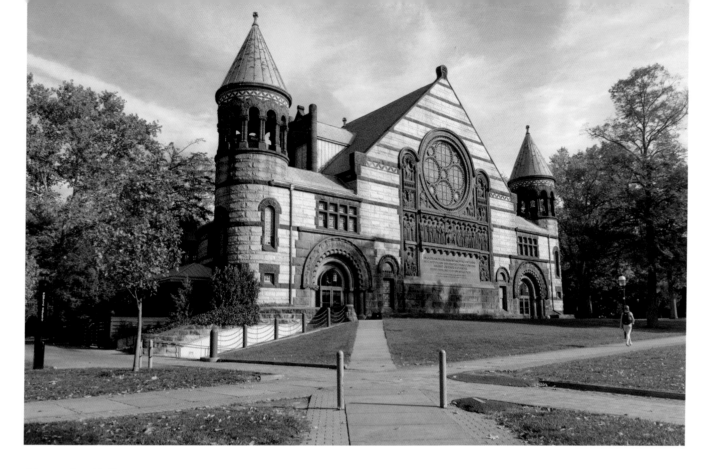

Alexander Hall

Commencement ceremonies mark the students' graduation and thus the beginning of their careers. In the early days, commencement was celebrated with much pomp in the First Presbyterian Church, featuring a multitude of speeches and debates in Latin, as was the custom of the time. Held in the fall, after the harvest, the day soon turned into a festival day for townspeople and farmers from far and wide. The raucous crowds were surely one of the reasons why graduation was eventually moved to late May in the 1840s.

Thanks to a gift by Harriet Crocker Alexander, Alexander Hall was built in the early 1890s to accommodate the growing student body at commencement and other major events. Designed in the Richardsonian Romanesque style by William A. Potter, the look went out of fashion almost immediately upon its completion. Thirty years after its construction, the university had outgrown Alexander Hall as well, and the exercises were moved to the lawn in front of Nassau Hall.

The interior space was significantly renovated and renamed Richardson Auditorium in 1984–'85 and is now the university's main venue for musical performances by the Princeton University Orchestra, world-class musicians, and community organizations.

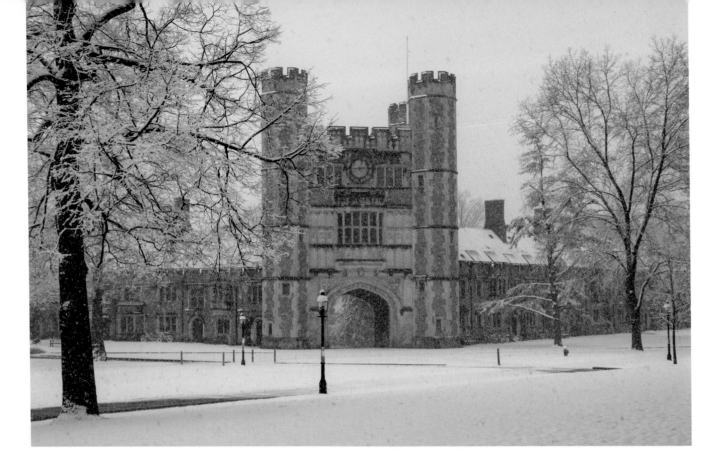

Blair Hall and Tower

Built by Anglophile architects Walter Cope and John Stewardson and completed in 1898, Blair Hall and Tower are considered some of the finest examples of Collegiate Gothic. The architects utilized the natural slope behind the hall to design a "wall dormitory" that enclosed the campus on its western side and separated it from the railroad station. Students and other visitors arriving by the local train, known as the Dinky, mounted steep steps, and entered campus through the massive and ornate Blair Arch.

The railroad station has been moved several times in the last century—most recently, a new station has been built on Alexander Street—but Blair Hall remains an imposing, iconic building. Its arch is one of the most popular sites for "arch sings" by the university's numerous a cappella groups.

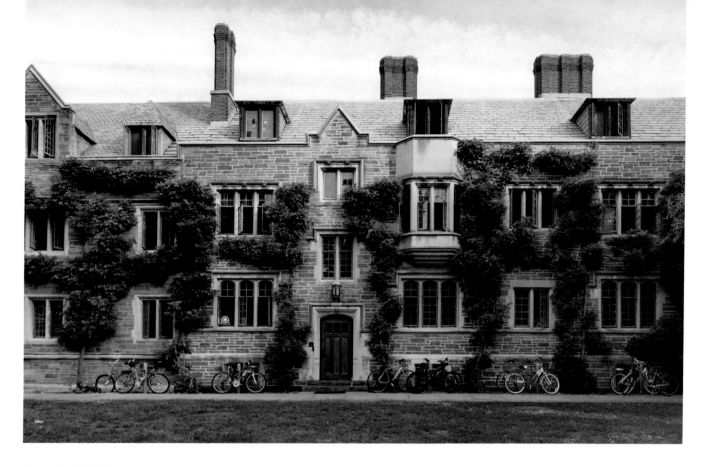

Campbell Hall

In this northwestern part of the central campus, the buildings feature crenellations, oriel windows, and flat Tudor arches. These are all characteristics of the medieval Collegiate Gothic style of Oxford and Cambridge Universities, a style that Princeton, back in 1896, chose to emulate.

The decision to embrace a style popularized in the 1500s may seem surprising; however, the leaders of the nascent university not only hoped that the Collegiate Gothic style's beauty would prove inspiring to the students, but also that it would add centuries to their young institution and declare to the world that Princeton was indeed a university. At a time of great changes—rising immigration and the advent of communism, to name a few—the focus on the Gothic also reflected a belief in the superiority of Anglo-Saxon heritage.

As the building activity on campus increased, many felt that a unified vision for the campus was needed, so in 1907 the university's first supervising architect, Ralph Adams Cram, was hired. Cram worked at Princeton for more than twenty years, leaving a lasting legacy. Campbell Hall (pictured) is one of his buildings.

Campbell Hall merges almost imperceptibly into Joline Hall on the left, which was built more than twenty years later by Charles Z. Klauder.

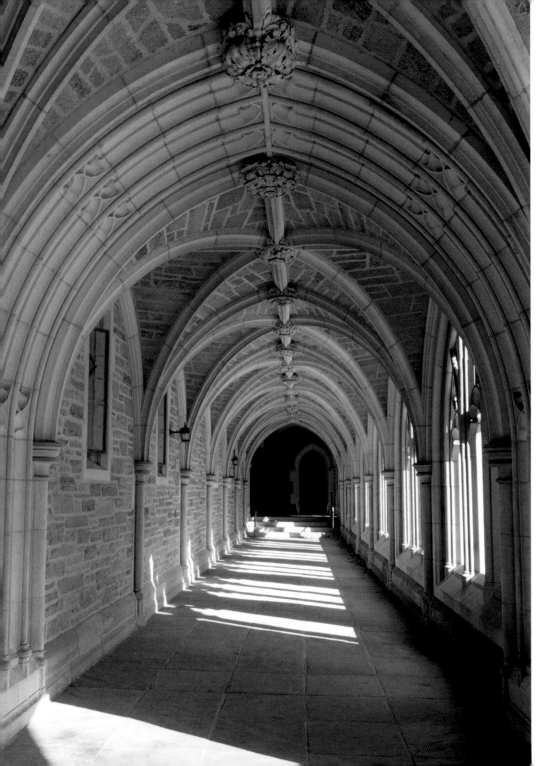

## Holder, Hamilton, and Madison Halls

Princeton's Gothic revival is considered to have reached its zenith with the construction of Holder, Hamilton, and Madison Halls, which were inspired by the medieval quadrangles of Oxford. The Holder Hall quadrangle is dominated by Holder Tower, modeled after the crossing tower at Canterbury Cathedral. An archway to Hamilton Hall and Court leads through the magnificent cloister (pictured) on the western side of the courtyard. The complex of dormitories and dining rooms, begun in 1908, was designed and built over a period of almost ten years by architects Frank Day and Charles Z. Klauder. Klauder, along with Day until the latter's death in 1918, would significantly shape Princeton's campus, designing more than eighteen buildings.

As Collegiate Gothic became the dominant architectural style at Princeton, the university also embarked on a unified landscaping plan. Beatrix Farrand, creator of the new Graduate College grounds, became the university landscape gardener in 1915. She favored simple plants that would enhance buildings and keep the grounds open, and her signature became espaliers: shrubs and trees trained to climb the walls. While only some of the original plantings still remain, primarily at the Graduate College, her principles and techniques are often still employed.

Holder Cloister on the western façade of Holder Court

## Holder Tower

Both Holder Hall and Tower were gifts of Margaret Olivia Sage, one of the many female donors who have supported the school over the years. A wealthy widow and astute investor, she became one the country's most important female philanthropists, founded the Russell Sage Foundation for Social Betterment, and supported a variety of causes, especially educational institutions and women's organizations.

The cost for both buildings was daunting, so the architects searched for affordable local materials. They chose Princeton stone (Lockatong argillite), a red, greenish, yellowish, or purple stone that was quarried just a few blocks away at Ewing and Spruce Streets. The architects closely supervised the configuration of the multicolored blocks to make sure that the final effect was pleasing. They succeeded, and argillite soon became very popular and was widely used across campus.

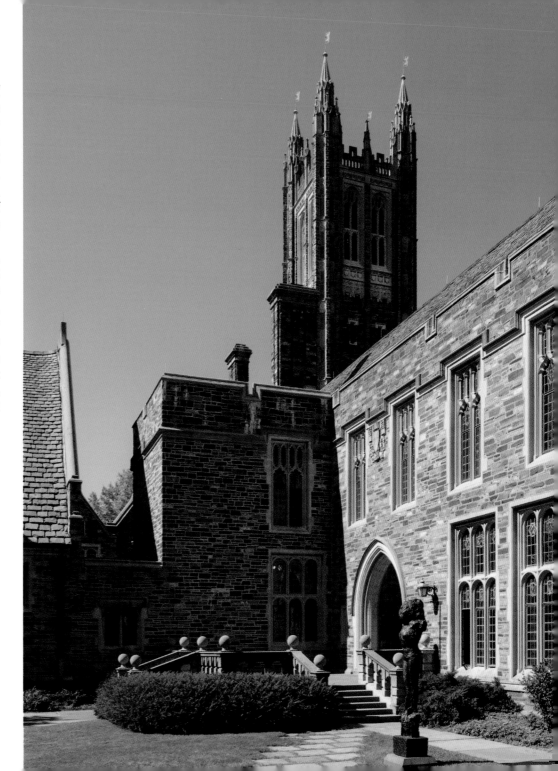

Holder Tower as seen from Hamilton Court, Princeton University. Also visible in the foreground: *The Bride*, 1956–61, by Reg Butler.

## Madison Hall

The task of feeding students had challenged the college for many years. The food was poor and costly, and in 1856 the school's refectory was forced to close. As students started organizing their own meals, elite off-campus eating clubs sponsored by alumni began to take shape.

When Woodrow Wilson assumed the presidency of Princeton, he wanted to make it possible for all students to eat on campus and, in a first step, reestablished a dining hall, or "commons," for freshmen and sophomores. But ultimately he dreamed that students of all four classes would live and eat in "colleges," forming small communities around a Gothic quadrangle: his so-called Quad Plan. When alumni realized this would in effect abolish the eating clubs, they were aghast—and the plan failed.

A new commons, Madison Hall, was built by Day and Klauder in 1916 and consisted of five separate dining rooms arranged around a central kitchen and serving all four classes. Decades later, in 1981, Madison Hall was completely renovated to serve the two new residential colleges, Mathey and Rockefeller, as dining and common rooms—a belated implementation of Wilson's idea.

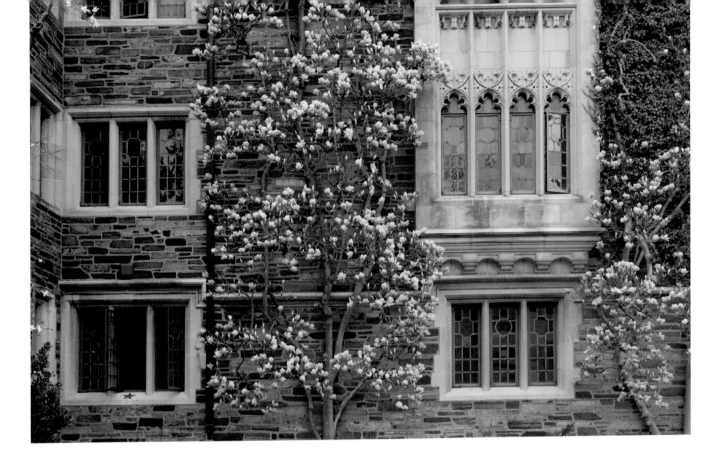

## Princeton at War

The major wars have all touched the school. Enrollment has dipped, battles have been fought on campus, and students have bid each other goodbye only to meet again on the battlefield.

In 1942, when the majority of students were drafted to fight in World War II, the university opened its doors to the military. Almost 20,000 men (and some women) were trained in programs that the US Army and Navy operated on campus as well as some that were taught by university personnel. In addition, many faculty members and graduate students — especially in mathematics and the sciences—worked on governmental research projects to support the war effort.

The bronze stars adorning many window sills (bottom left of image) are a memorial to fallen students and alumni and mark their dorm rooms, a tradition that started after World War I.

45

# WALK TWO: Downtown Princeton

Princeton's charm lies not only in its eclectic mix of shops and restaurants but also in its diverse architecture and rich history. Join us as we trace the town's evolution from Quaker settlement to bustling colonial carriage stop to sophisticated Ivy League enclave.

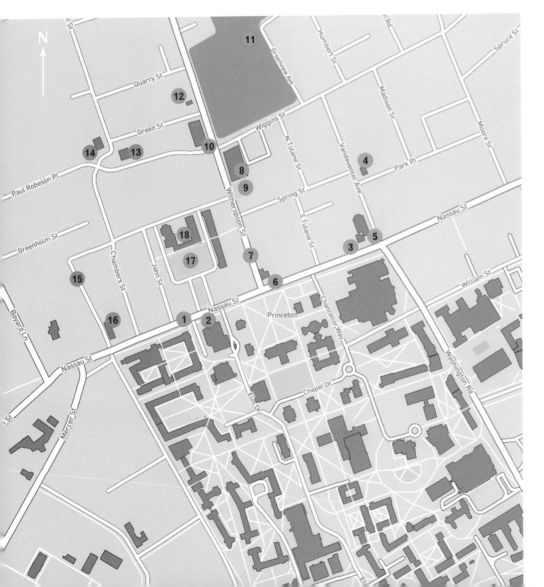

The main entrance to the cemetery is on Greenview Avenue; a second entrance on Witherspoon Street is not always open.

To extend your walk, you may wish to explore the "tree streets" (Chestnut, Linden, Maple, Pine) and two pocket parks: Barbara Boggs Sigmund Park and Quarry Park.

Mapbox

© Mapbox, © OpenStreetMap

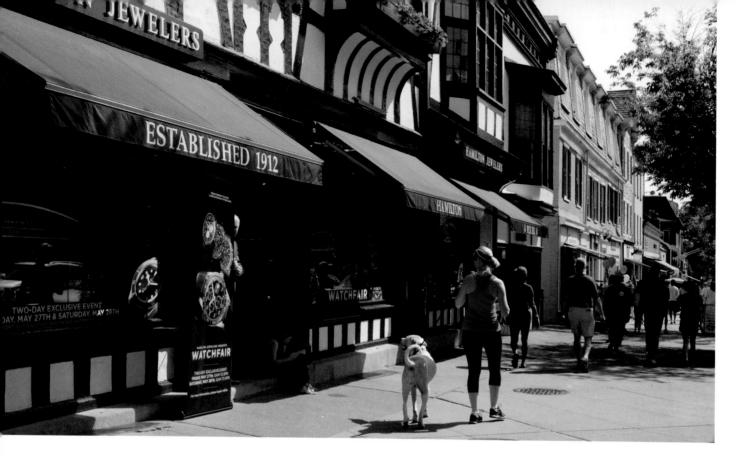

Nassau Street

Princeton's main thoroughfare, Nassau Street, represents another homage to Prince William of the House of Orange-Nassau and demarcates the line between the town and the university. In the eighteenth century the street divided Somerset and Middlesex Counties; scofflaws from one county could simply cross Nassau Street to flee law enforcement officers lacking jurisdiction in the neighboring county. In 1813, Princeton sought and was granted a borough charter by the state. The college may have led this effort to improve the town's orderliness and stability, for as a borough, Princeton could select a mayor and aldermen and build its own jail. Princeton Borough continued to straddle two counties until 1838, when Mercer County was carved out of Somerset, Hunterdon, Middlesex, and Burlington counties. Shortly thereafter Princeton Township was created, a doughnut-like area of land surrounding Princeton Borough. The two Princetons coexisted for almost two centuries, with residents only voting to consolidate into a single municipality in 2013.

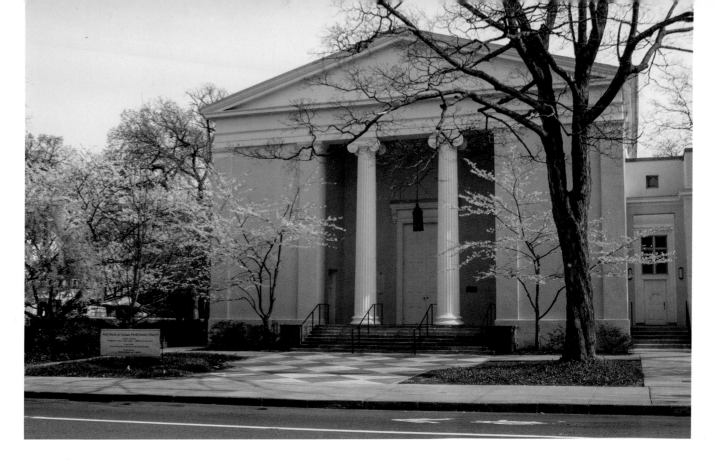

Nassau Presbyterian Church

Princeton's first inhabitants were Quakers who settled along the Stony Brook at the end of the seventeenth century; yet within four or five decades Presbyterianism had begun to ascend as the dominant religion of the area. The latter faith gained a crucial foothold when the College of New Jersey, founded in Newark as an academy for training Presbyterian ministers, gained a permanent home in Princeton. Initially the college's students and faculty as well as local Presbyterians worshipped at a chapel in Nassau Hall, but by 1762 the college and local community joined forces to establish a separate sanctuary, First Presbyterian Church (today Nassau Presbyterian). The church before you is the third incarnation of the original, the first two edifices having burnt down in the early nineteenth century. The church was built by Charles Steadman in 1836, featuring an imposing façade designed by lauded Philadelphia architect Thomas U. Walter.

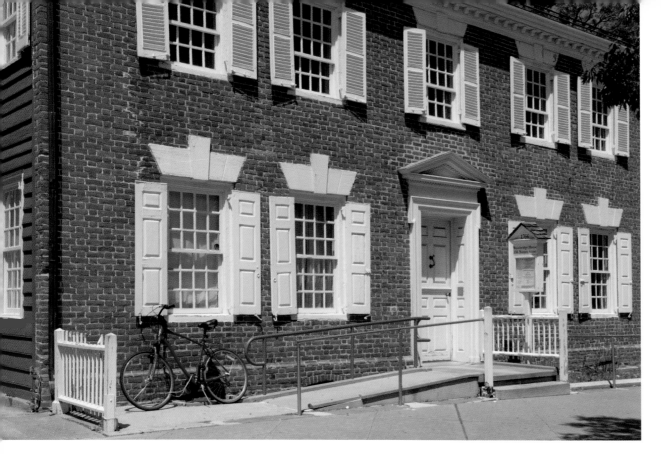

## Bainbridge House

Built in 1766 for Job Stockton, a wealthy tanner, Bainbridge House represents one of the loveliest, intact examples of colonial Georgian architecture in Princeton. The two-story, five-bay house, complete with brick façade, was extremely grand for its time, rivaled only by the residence of Princeton's president (now Maclean House). The main decorative features are the triangular pediment over the doorway, keyed wooden lintels above the windows, and a wooden modillion cornice under the roofline.

Bainbridge House, owned by the university since 1877, has served many purposes over the years. It housed the Princeton Public Library for over five decades and later the Historical Society of Princeton, which is now at the Updike Farmstead. In the future, Bainbridge House will likely provide office and program space for the Princeton University Art Museum and be used to promote awareness of both the museum and local arts and culture.

Beatty House

Another fine example of Georgian architecture is Beatty House, named for Colonel Erkuries Beatty, a Revolutionary War veteran. The structure was originally on Nassau Street across from Bainbridge House but was moved to its current location in 1875. Moving houses was a rather commonplace occurrence in Princeton; over 200 buildings of every type were moved in Princeton during  the nineteenth and early twentieth centuries. While this practice may seem surprising to us today, it was often cheaper to move an existing house than to build a new one, and simple technology along with readily available land made moving buildings an attractive option. The continual expansion of the university and, later, the Princeton Theological Seminary, propelled this moving mania as both institutions sold or auctioned off unwanted houses to buyers who then carted away their acquisitions, freeing up land for new—or sometimes other moved!—buildings.

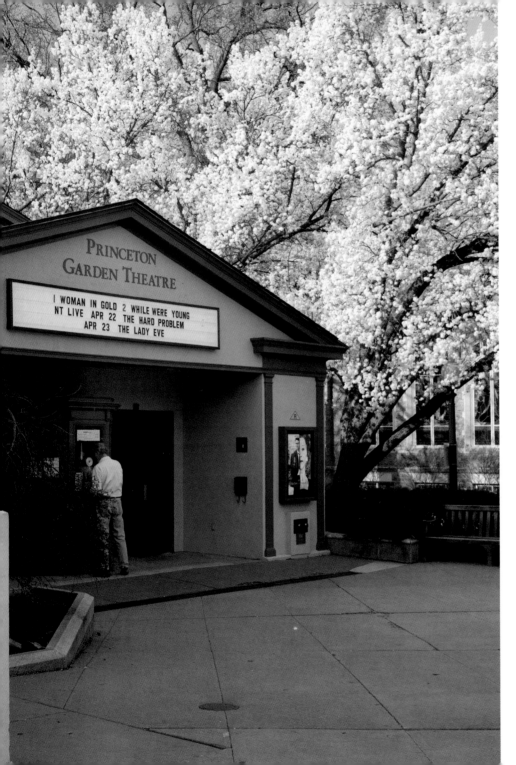

## Princeton Garden Theatre

While Princeton boasted three downtown movie theaters at one point, its lone remaining venue is the Garden Theatre. The Garden, named for a rose garden that once belonged to neighboring Bainbridge House, opened in 1920 with a showing of the silent film *Civilian Clothes*, complete with live orchestra. It was originally used as a performance space for Princeton University's Triangle Club; when the latter moved to the McCarter Theatre, the Garden became a film house and changed hands several times in the ensuing decades. Today the theater is owned by the university and is run by Renew Theaters, a nonprofit specializing in art, independent, and classic films.

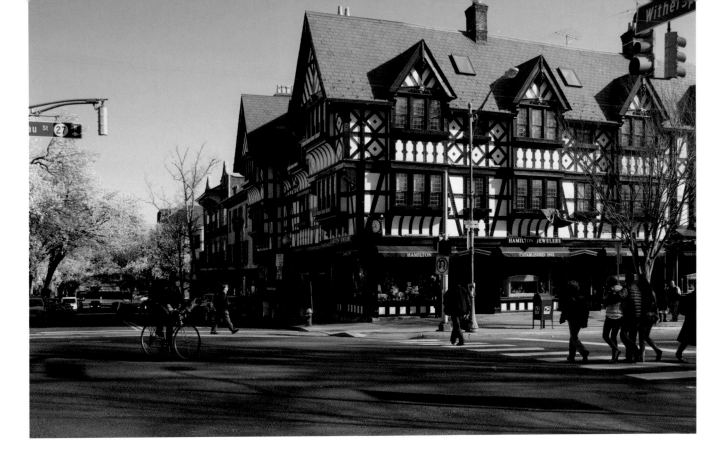

Lower Pyne

Medieval revival architecture became popular in Princeton toward the end of the nineteenth century, and timber-framed Tudor Lower Pyne once had a twin on the opposite side of the street. Both buildings served as dormitories and were named for one of the university's most magnanimous donors, Moses Taylor Pyne. The latter also funded White City, a set of Tudor homes now known as the Broadmead neighborhood. Pyne's fondness for both the Tudor and Collegiate Gothic styles is not surprising, as they represented his love of a particular vision of English life: the Gothic campus flanked by the quaint Tudor village.

## Witherspoon Street

The T at Witherspoon and Nassau Streets forms the heart of Princeton's historic downtown. The name Witherspoon honors the university's sixth president John Witherspoon, whose able leadership for over two decades strengthened the college greatly. The Reverend Witherspoon lived at a farm called Tusculum in the later years of his presidency and would ride his horse home from Nassau Hall, guided by a light kept by his daughter in the rose window in the attic, or so the story goes. Witherspoon Street names the route he took from the college to the farm.

Today Witherspoon Street is bustling in every season with students, locals, and out-of-town visitors who come to eat and shop. The commercial strip, especially impressive in spring when the callery pear trees burst into bloom, is anchored at the far end by the Princeton Public Library and the Arts Council of Princeton, and then extends into Princeton's historic African American neighborhood.

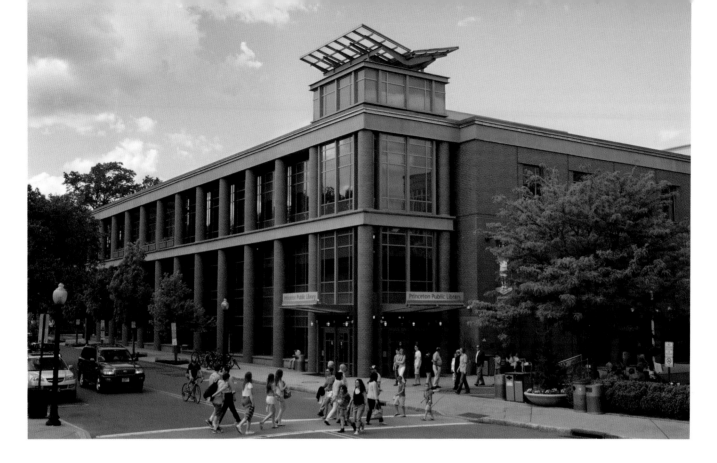

Princeton Public Library

The Princeton Public Library plays a vital role in the community. The beautiful George and Estelle Sands Library building, designed by Hillier Architecture, opened in 2004 and offers a sweeping selection of books and other materials and provides media access, meeting spaces, conference rooms, a children's play area, café, and bookstore. The library staff also produces a tremendous number of programs for patrons of all ages, including employment seminars, science demonstrations, author talks, craft workshops, and film series. Given this astonishing array of programs, the Jorge Luis Borges quote inscribed on the northern exterior wall seems apt: "I had always imagined paradise as a kind of library."

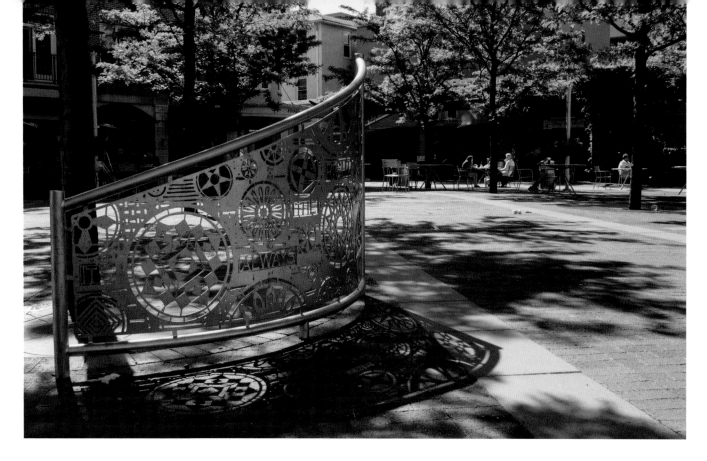

## Hinds Plaza

This attractive brick plaza is named after Albert E. Hinds, native son and pillar of the Princeton community for many decades. Hinds spent the majority of his 104 years in Princeton, grew up in the Witherspoon-Jackson neighborhood, and returned after college to work a variety of jobs and serve as a dedicated and active citizen. Hinds' motto was "It's always the right time to do the right thing," a philosophy inscribed on the gateways that are permanently open to symbolize his spirit and life. The plaza is not only the site of the farmers market but also the annual Children's Book Fair in the fall, salsa dancing in the summer, and people-watching all year long.

*Albert E. Hinds Memorial Gateways*, 2013, by Tom Nussbaum. Hinds Plaza, Princeton

## The Arts Council of Princeton
## Paul Robeson Center for the Arts

The Paul Robeson Center for the Arts is home to the Arts Council of Princeton (ACP), and is diagonally across from the Princeton Public Library. Founded in 1967, the ACP offers a wide range of classes, performances, exhibitions, and community outreach programs to fulfill its mission of "Building Community through the Arts."

The center was named after Paul Robeson (1898–1976), the renowned African American Renaissance man who grew up in the adjacent, historically black Witherspoon-Jackson neighborhood. A Rutgers University valedictorian and All-American football star, Robeson studied law at Columbia while also performing in off-campus productions. He gained international fame during the 1920s and 1930s for his starring roles in films such as *Showboat*, his rendition of "Ol' Man River," and his critically-acclaimed performance in *Othello*. Robeson was an early civil rights advocate and fought against lynchings, racial discrimination, and fascism; as a result he was blacklisted during the McCarthy era, after which his career was never fully restored. Paul Robeson often returned to his hometown over the years and, according to his contemporaries, "never forgot Princeton" (Smith 2014, 29).

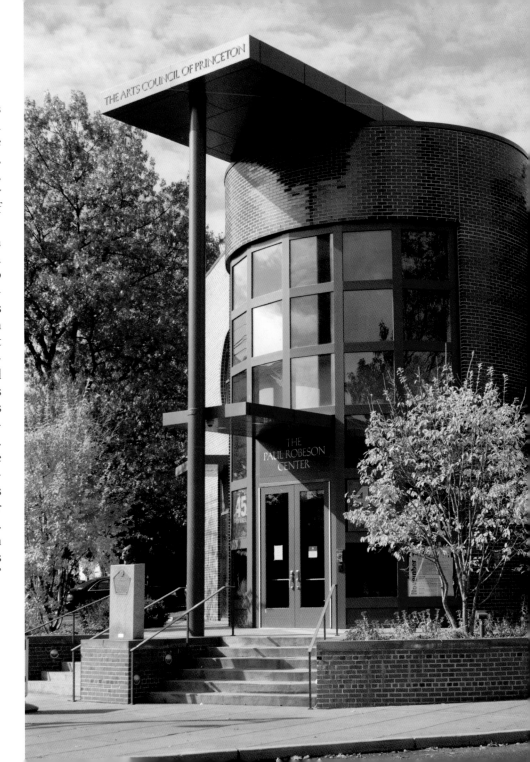

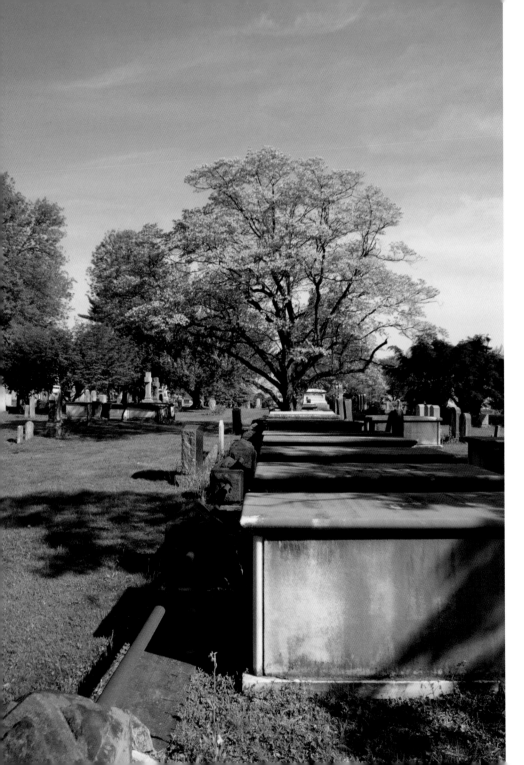

## Princeton Cemetery

Like many colonial villages, Princeton's oldest cemetery lies near its historic center. The cemetery began as a one-acre parcel, then grew over time—thanks to generous gifts of land—and today covers approximately nineteen acres. Originally established by the College of New Jersey, by the 1780s the cemetery was conveyed to First Presbyterian Church (now Nassau Presbyterian Church), which still owns and operates it today. A walk through the grounds quickly reveals that people of all faiths are buried here.

The cemetery's oldest section can be found near the intersection of Wiggins and Witherspoon Streets. Here weathered head-stones bear the names of Princeton's earliest founding families: Bayard, Berrien, Leonard, Stockton, Skillman, Terhune, Mershon. Many university presidents and luminaries were laid to rest within its wrought-iron fences, as well as countless lesser-known residents.

## Witherspoon Street Presbyterian Church

Witherspoon Street Presbyterian Church stands in the center of Princeton's historic African American neighborhood. One of several longstanding black churches, it was founded in the aftermath of the 1835 fire at First Presbyterian Church, for when First Presbyterian was being rebuilt, African American members of the congregation were dismissed and asked to form their own church. They founded the Witherspoon Street Presbyterian Church (WSPC), which in the mid–twentieth century was one of the first churches in Princeton to become more racially integrated. Over the past six decades, sustained efforts have been made to repair the relationship between First Presbyterian (now Nassau Presbyterian) and WSPC.

The church contains several beautiful stained glass windows, one of which is dedicated to Paul Robeson's grandmother, Sabra Robeson, a former slave. Another window honors Betsey Stockton, a Stockton family slave who was manumitted, became a teacher, and then helped to establish the first public school for African American children in Princeton.

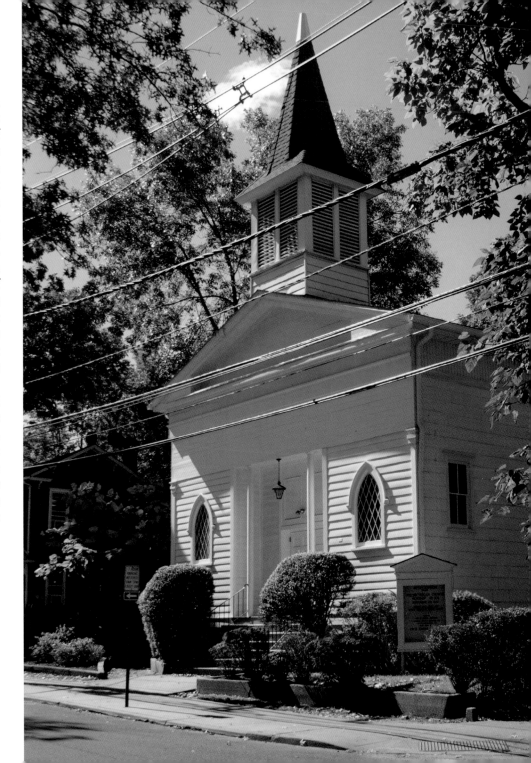

## The First Baptist Church of Princeton

Snugly tucked on a triangular plot between John, Robeson, and Green Streets, First Baptist Church is one of several historically African American churches in Princeton. Originally called Bright Hope Baptist Church, the congregation was organized in 1885.

The plaza in front of the church was dedicated to the Rev. Martin Luther King Jr. in 1969 and features a stainless steel sculpture by David Savage of Princeton.

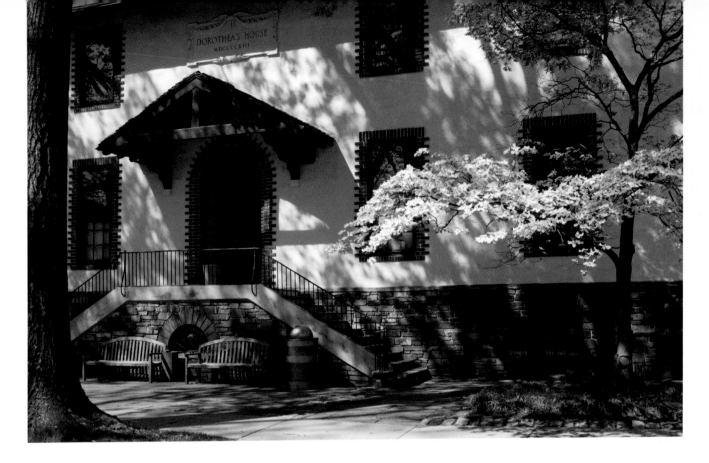

## Dorothea's House

The impressive Italianate building across from First Baptist is Dorothea's House, a 1913 memorial to Dorothea van Dyke McLane, who died at age twenty-three in childbirth. Dorothea McLane had tutored and taught Sunday school to Italian immigrant children and also helped their parents settle into American life. After her death, McLane's father, Princeton University Professor Henry van Dyke, and her husband, Guy Richard McLane, sought to honor and continue her work with the Italian immigrants who were streaming into Princeton at the turn of the century. Dorothea's House served as a social and resource center for Italian immigrants for many decades; today the building provides space for Italian language classes and cultural programs as well as for family services run by local social agencies.

## Bank Street

For a glimpse of an earlier Princeton, take a walk down Bank Street. This narrow lane is a vestige of the late nineteenth century when horse-drawn wagons, rather than cars, dominated Princeton's streets. The houses were built for college students and working-class folk in the Victorian era. Exemplars of the then-popular Queen Anne style, they feature detailed, fanciful wooden decorations and tiny porches.

## Dutch Revival Bank Building

Bank Street takes its name from this Dutch-style building with its stepped gable and ornately decorated façade. Originally built in 1897 for Princeton Bank and Trust, the building was allegedly modeled after the sixteenth-century meat market of Haarlem, Netherlands.

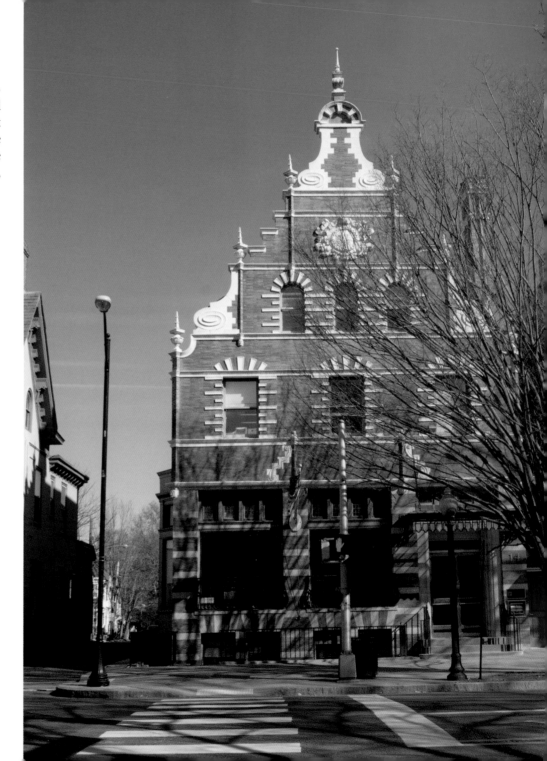

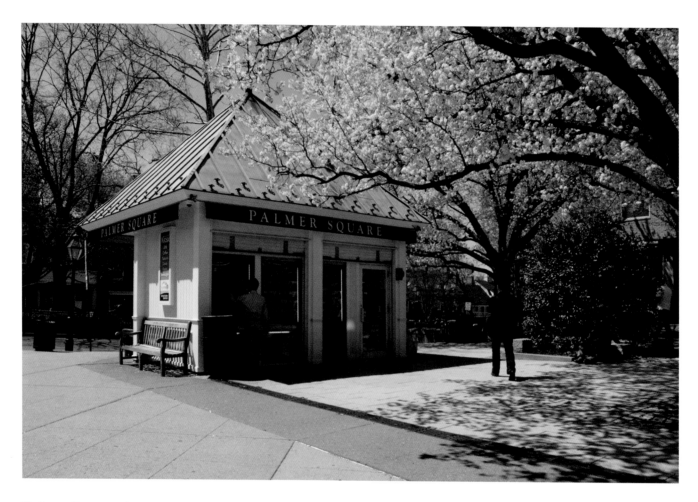

Palmer Square

Palmer Square represents the picturesque center of Princeton: a tidy square of green edged by fashionable shops and eateries. Once a working-class neighborhood lined with old wooden houses and tenements, the area began to be redeveloped in 1929 with financing from New Jersey Zinc Company magnate Edgar Palmer, Class of 1903. Sadly, the project, which was backed by the town's elite as well as university officials, called for the relocation of the area's residents, many of whom were African American, a betrayal that continues to be felt today.

Palmer and his associates envisioned a charming, European-style town center with town hall, post office, library, hotel, apartment houses and office space, several parks, and numerous shops and restaurants away from busy Nassau Street. The plans were unveiled in 1929, but the onset of the Great Depression delayed construction until 1936. In the end, the whole project was completed in several phases over many decades.

The small plaza known as Tiger Park features a bronze tiger memorial to Edgar Palmer, *Palmer Tiger* by Charles Knight.

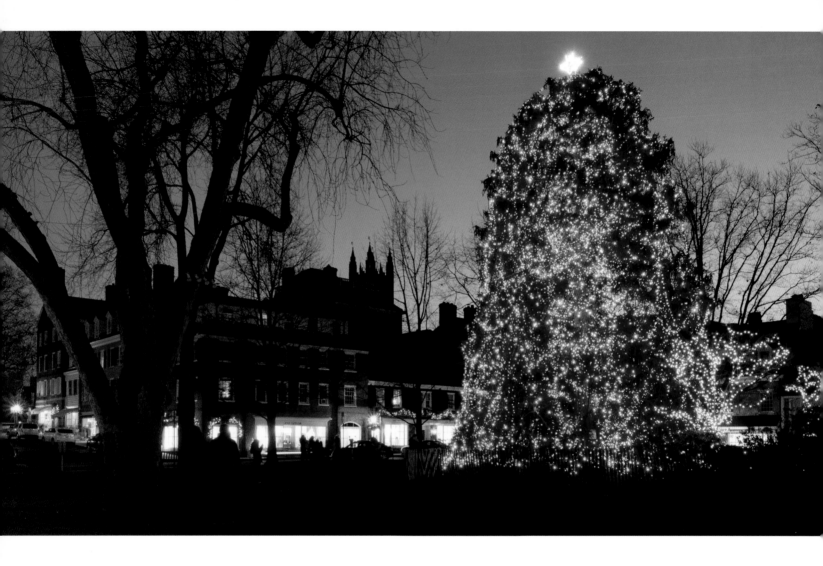

Residents and visitors alike flock to Palmer Square to browse, shop, loll on the grass, eat ice cream, and watch the world go by. The Green provides a lovely space for events throughout the year, including performances at Communiversity (the annual springtime town-gown festival), weekly summer concerts, and the popular JazzFeast in September. The towering Christmas tree in December dazzles both young and old.

Nassau Inn

Princeton began as a way station between New York and Philadelphia, featuring several inns. The Nassau Inn, first named "At the Sign of the College" and later "College Inn," was originally located on Nassau Street, then torn down and rebuilt on the present site. Recently renovated, the inn hosts visitors and alumni all year long and remains a favorite place for weddings, reunions, and conferences. Locals know the in-house restaurant, The Yankee Doodle Tap Room, is a good choice for a quick bite or glass of beer. Many guests make a special point of checking out the Work Progress Administration–era mural by Norman Rockwell behind the bar and the mementos of the original inn.

## WALK THREE: West Around Mercer Hill

Much of the land in Princeton's western section originally belonged to the Stocktons, one of Princeton's oldest families. On this walk we begin at the ancestral home, Morven, then wend our way through historic neighborhoods, catching a glimpse of this influential family's story.

1. Morven Museum and Garden
2. Princeton Battle Monument
3. Palmer House
4. Mercer Street
5. Ivy Hall
6. Trinity Church
7. Einstein House
8. Marquand Park and Arboretum
9. Edgehill Street
10. Library Place and Boudinot Street

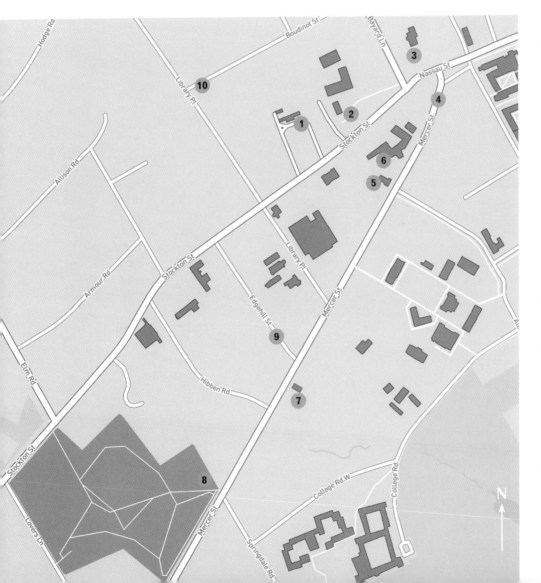

Parking is available at Morven for museum visitors or in the residential areas behind the museum.

One entrance to Marquand Park can be found on Mercer Street, across from Springdale Road.

To extend your walk you might consider exploring the neighborhood beyond Library Place. A fun fact: the fence at 12 Morven Place used to surround the front campus of the university, prior to the installation of FitzRandolph Gate.

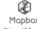

Mapbox
© Mapbox, © OpenStreetMap

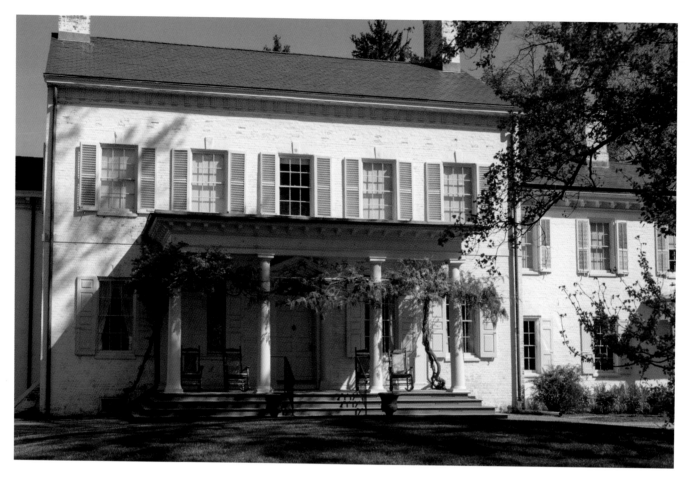

Morven Museum and Garden

Morven was built by Richard Stockton, scion of one of Princeton's first Quaker families and signer of the Declaration of Independence. The name, which means "big mountain" and comes from an Irish epic poem of the eighteenth century, was chosen by his bride, the poet Annis Boudinot Stockton. Built in the 1750s, Morven remained in the Stockton family for five generations, enduring fires, the Battle of Princeton, and a variety of renovations and additions. In the twentieth century Morven served as the official residence of New Jersey's governors until 1981 when Drumthwacket assumed this role. The house was then transformed into a museum and education center.

Visitors may tour the first floor of Morven, which displays art and artifacts from the Stocktons' era as well as portraits of other notable residents. The second-floor galleries are reserved for changing exhibitions. The gardens, a treasured feature since Annis Stockton's day, remain free and open to the public. In addition to exhibits, Morven hosts a variety of events throughout the year.

## Princeton Battle Monument

Although the history of the Battle of Princeton has often been overshadowed by the stories of larger engagements, this conflict arguably changed the course of the American Revolution. The patriots' stealthy entrance into Princeton—made possible by General Washington's deployment of spies—resulted in a resounding defeat of the British and provided a sorely needed boost in morale to the Americans.

Over a century later, Princetonians finally decided to commemorate the battle; and in 1922 the monument was unveiled. Designed by architect Thomas Hastings and sculptor Frederick MacMonnies, this massive limestone block was hand carved by Italian immigrant stonemasons. The monument depicts George Washington on horseback with Lady Liberty helping him rally his exhausted troops and also portrays the dying General Mercer, for whom Mercer County and nearby Mercer Street are named. The unveiling was accompanied by much pomp and circumstance and even an appearance by President Warren G. Harding!

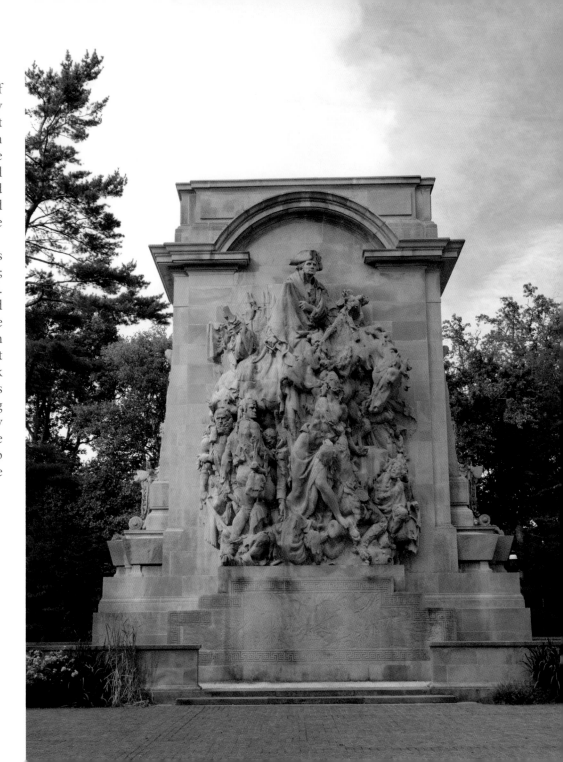

Palmer House

A brick wall encircles another grand Stockton family home, Palmer House, built for Robert Field Stockton, a career navy man known as "The Commodore" and grandson of Richard Stockton the Signer. Commodore Stockton became known as "Fighting Bob" in the War of 1812 and later led an expedition to Africa, which eventually inspired the creation of the state of Liberia. Stockton married Harriet Maria Potter in 1823, a fortuitous match as his wealthy father-in-law, John Potter, would soon become his business partner. Returning to Princeton with his bride, Stockton commissioned Charles Steadman to build his new home. Some of Steadman's favorite stylistic elements can be seen on the façade: columns with Ionic-inspired capitals as well as a beautiful fanlight transom above the front door.

The house now bears the name of Edgar Palmer, whose family deeded it to the university, and is used as a guest house.

Mercer Street

Mercer Hill is one of Princeton's historic districts bounded by Stockton, University, and Mercer Streets. The latter is a charming, old-fashioned avenue featuring many white clapboard houses built by Charles Steadman, the self-taught carpenter, architect, and builder who became so influential in Princeton. Like many architects of his time, Steadman relied on pattern books for ideas and inspiration; his buildings are replete with elements of the Federal and Greek Revival styles that were sweeping the nation.

When Canal Street (now Alexander Street) was created to link Nassau Street and the Delaware & Raritan Canal, Steadman became one of Princeton's first real estate developers, buying up land along the new route and putting up homes for the town's skilled workers. He also built grander houses and churches all over town; over forty buildings attributed to Steadman remain, demonstrating his enduring mark on the town's much-beloved look.

Ivy Hall

On leave from the navy, Commodore Stockton returned to Princeton in 1828 and sought to realize a longtime family dream: the building of a canal in New Jersey—similar to New York's Erie Canal—a project initially dubbed "Stockton's Folly." He, along with others, lobbied the New Jersey legislature to grant a charter for a canal that would connect Pennsylvania to New York. Stockton and his father-in-law invested heavily in the canal, which took more than four years to build and exacted a steep toll on the mainly Irish immigrants who dug the channel with picks and shovels. In 1834 the Delaware and Raritan Canal opened and soon became a boon to commerce. Passenger travel to New York and Philadelphia improved as well when, only a few years later, tracks for the railroad were laid on the banks of the canal.

Ivy Hall, at the top of Canal Street (now Alexander Street), became the headquarters of the Joint Companies, a merger between the canal and railroad companies, and later lent its name to the Ivy Club, one of the university's eating clubs, which was founded here. At present, Ivy Hall belongs to Trinity Church next door.

## Trinity Church

A convert to his wife's Episcopal faith, Robert Field Stockton made another contribution to Princeton by helping to build Trinity Church, Princeton's first Episcopal house of worship. Founded in 1833, the original wooden church was built by Charles Steadman; however, reflecting a shift in architectural tastes, a new Gothic Revival stone edifice was built forty years later. Ralph Adams Cram, an Episcopalian and Princeton's influential supervising architect, significantly enlarged the church in the early twentieth century.

After ten productive years in Princeton, Commodore Stockton resumed his active duty with the navy in 1838. While serving in England, Stockton met the esteemed mechanical engineer John Ericsson, who was working on screw-propelled vessels. Still concerned with the canal back home, Stockton commissioned America's first propeller steamer, which would serve as a tugboat on the canal for years to come.

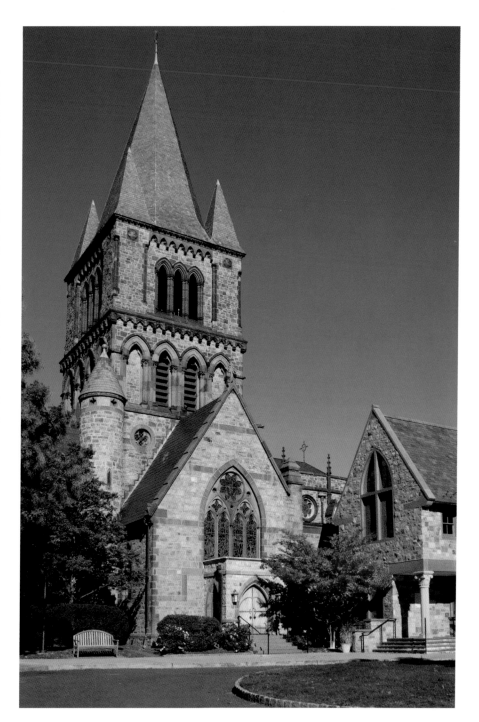

Einstein House

No former Princeton resident is as beloved as Albert Einstein, who lived in this house at 112 Mercer Street. From here he went on daily walks to his office at the Institute for Advanced Study (IAS) and through town, memories still fondly cherished by longtime locals.

Einstein earned global fame as a Nobel-prize winning physicist and active peace advocate. After immigrating to the US he tirelessly helped other scholars and artists escape fascism in Europe and emigrate to the US. Less well known is his sustained support of African Americans in their fight for equal rights. Friendly with prominent artists and intellectuals such as Paul Robeson, Marian Anderson, and W. E. B. Du Bois, he worked steadfastly to expose and end racism in his new home country.

Einstein's step-daughter Margot bequeathed the house to IAS upon her death and it remains a private residence for faculty. A selection of Einstein's belongings and furniture, donated by the institute, is on view at the Historical Society of Princeton at Updike Farmstead.

## Marquand Park and Arboretum

This tranquil, seventeen-acre park and arboretum features over 170 varieties of trees, paved walks, a picnic area, and a playground, the latter being a favorite among Princeton's little ones for its large sand area. In 1842 this land was purchased by Judge Richard Stockton Field, a great-grandson of Richard Stockton, a local signer of the Declaration of Independence. Judge Field built an elegant Italianate villa designed by John Notman—one of several grand homes and villas constructed by the sprawling Stockton clan around this time.

By the end of the nineteenth century, the old estates in the west had been sold to several prominent families who had recently arrived in Princeton. In 1885, Judge Field's former property was bought by Allan Marquand, professor of art history at Princeton, who named his new home Guernsey Hall. Marquand's descendants donated the land that became Marquand Park to Princeton in 1953, when the estate was subdivided and Guernsey Hall was converted into condominiums.

Edgehill Street

Once upon a time this area formed part of the vast landholdings belonging to the Stockton family. The first Richard Stockton, grandfather of Richard Stockton the Signer, lived in this house at 32 Edgehill Street, known as "the Barracks," when he first moved to the area at the end of the seventeenth century.

This may well be Princeton's oldest dwelling. The name "the Barracks" refers to the fact that it was likely used to house soldiers during the French and Indian Wars.

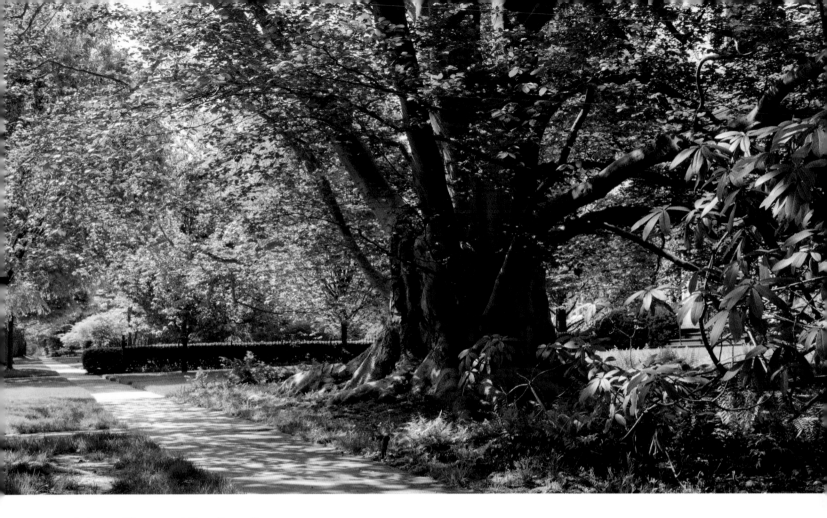

## Library Place and Boudinot Street

At the end of the nineteenth century, Princeton was booming. With trains running to New York City and Philadelphia and a trolley line offering service to Trenton, the town experienced an influx of new residents. When the old Morven estate was subdivided, a new neighborhood evolved, dotted with houses in a variety of revival styles. In fact, many of the same architects who were also working for the university designed homes in this neighborhood, profoundly influencing its look. In this quiet area lined by towering old trees, one can still see some revival homes from that era.

# WALK FOUR: The University in the Twenty-First Century

While Princeton University remains steeped in tradition, change is perpetual as new fields of study emerge and facilities are added. On this walk we venture beyond the historic heart of the university to discover how the campus has developed and how science, sports, and student life have evolved over the past decades.

1. Andlinger Center for Energy and the Environment
2. Sherrerd Hall
3. Robertson Hall
4. Scudder Plaza
5. Princeton Stadium
6. Lewis Library
7. Frick Chemistry Laboratory
8. Princeton Neuroscience Institute and Peretsman Scully Hall
9. Carl Icahn Laboratory
10. Scully Hall
11. Bloomberg Hall
12. Whitman College
13. Transit Plaza and Arts Neighborhood
14. Wu Hall
15. Butler College
16. Frist Campus Center
17. 1879 Hall
18. Prospect Avenue

Metered parking is available on Prospect Avenue.

As this is a long walk, you might want to plan a snack break in the Arts Neighborhood or consider skipping this area and turning back after Whitman College.

To extend the tour to the east, continue down Prospect Avenue to Fitzrandolph Road and Broadmead Street, a neighborhood originally named "White City" after its once-white Tudor houses.

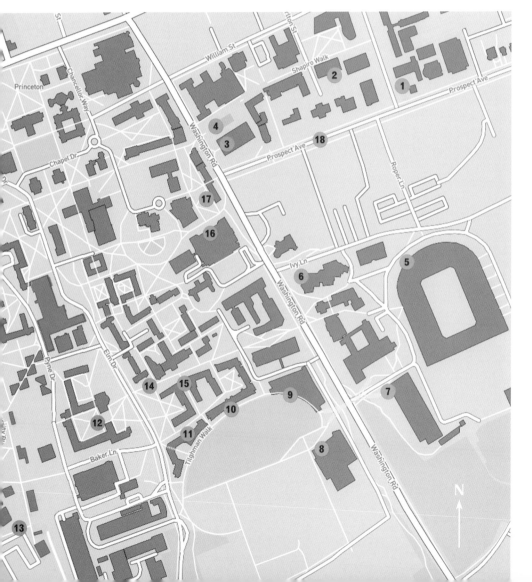

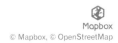

© Mapbox, © OpenStreetMap

## Andlinger Center for Energy and the Environment

We begin this walk at one of the newest buildings on campus. The Andlinger Center, founded in 2008 and funded by a gift from Gerhard R. Andlinger, Class of 1952, enables researchers from many fields to come together to tackle some of the world's most pressing energy challenges: sustainable generation, lasting storage, and efficient use of energy. Current projects range from making batteries out of concrete to using yeast to make fuel.

Opened in 2015, the new home of the Andlinger Center was designed by celebrated architects Tod Williams and Billie Tsien. Most of the 130,000-square-foot complex is below-grade, allowing it to blend into the neighborhood while promoting energy conservation. The most striking features also allude to the natural environment: the glass walls mirroring the sky and the sunken, elaborately planted gardens. The gray brick, while modern, carries on the Princeton tradition of carefully handcrafted masonry construction.

Sherrerd Hall

Sherrerd Hall was a gift from John "Jay" Sherrerd, Class of 1952, and his family. A "tiger of the finest stripe," as President Tilghman called him, Sherrerd served the university for many decades, including two rare consecutive ten-year terms as a university trustee (*PAW*, May 14, 2008). The building is the home of the Center for Information Technology Policy and the popular ORFE (Operations Research and Financial Engineering) department.

The building was designed by award-winning Los Angeles firm Frederick Fisher and Partners and completed in 2008. Breaking with the 250-year focus on masonry on campus, Sherrerd Hall is characterized by a mix of frosted and clear glass and offers a constantly changing reflection of trees and the Friend Center across the courtyard. The transparent parts allow a peek at the metal and light sculpture by Jim Isermann, an impressive centerpiece in the main stairwell.

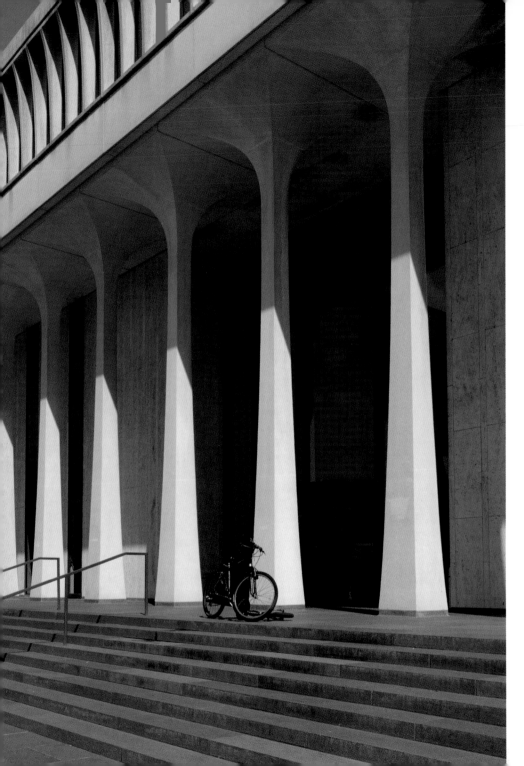

## Robertson Hall

"Princeton in the Nation's Service" ranks as one of Woodrow Wilson's most famous speeches, given in 1896 at the sesquicentennial celebration. One hundred years later, at the university's bicenquinquagenary, the motto was broadened to read "In the Nation's Service and in the Service of All Nations," and in 2016 it was expanded again—per alumna Justice Sonia Sotomayor's suggestion—to include all of humanity. It was in this spirit of service that the School of Public and International Affairs was originally founded in 1930.

The school received an enormous boost in 1961 when it received a stunning gift, at first anonymously. After more than a decade of speculation, the names of the donors, Charles S. Robertson, Class of 1926, and his wife Marie, were made public. Thanks to the endowment, the school was able to strengthen its graduate program and build a new home for the school: Robertson Hall.

President Goheen said he "was looking for a dramatic statement" when he commissioned Minoru Yamasaki, architect of the original World Trade Center in New York City (Maynard 2012, 185). The edifice, inspired by Greek temples of old and completed in 1966, was a shock to lovers of the neo-Gothic.

## Scudder Plaza

In front of Robertson Hall is Scudder Plaza. In warm weather, this is one of the most popular spots in town: students and families relax around the rectangular pool, enjoying the spray of James FitzGerald's Fountain of Freedom. The sculpture vaguely resembles the gnarled trees along the windswept coast of the San Juan Islands in Washington State that so inspired the Seattle artist and sculptor.

The prestigious School of Public and International Affairs was renamed the Woodrow Wilson School in Wilson's honor in 1948. For many decades, the former university and US president has been celebrated on campus through buildings, murals, and programs. His legacy, however, has come under intense scrutiny, as the university community struggles to reconcile his many achievements with new insights into his biases and discriminatory actions against African Americans, in particular.

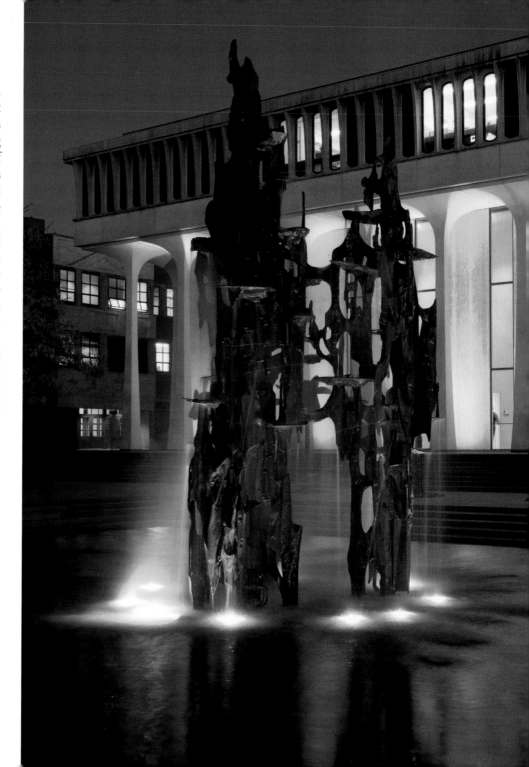

*Fountain of Freedom*, 1966, by James FitzGerald. Scudder Plaza, Princeton University

## Sports at Princeton

While students have always sought respite from their studies through games and sports on Cannon Green, athletics were long frowned upon by the faculty. The first basic gymnasium was finally constructed in 1859 with money from students, faculty, and President Maclean himself. Later, under President McCosh, a new gym—considered the best in the country—was built, and organized sports quickly became popular.

It was in 1869 that the first intercollegiate football game in the US was played between Rutgers and Princeton, although the game was played very differently than it is today. Football soon became a hit on campus and the players, who were wearing orange and black, became known for their ferocity and were nicknamed "tigers" by sports writers. Until the 1950s Princeton's footballers were quite a force, featuring talents like Hobey Baker and Dick Kazmaier. Today Princeton has a NCAA Division I football team and is a member of the Ivy League. In addition to football, the university offers a wide variety of sports at varsity, club, and intramural levels.

Fireworks on Community and Staff Day in fall. The most popular fireworks show in Princeton—a spectacular choreographed pyrotechnic display—takes place on Reunions Weekend in late May/early June.

## Princeton Stadium

The original and well-loved Palmer Stadium, one of the oldest stadiums in the US, was built in 1914 and bore witness to many historic games. Serious structural issues and functional deficiencies compelled its demolition in 1997, a decision that saddened many alumni and supporters. A year later, the new Princeton Stadium was erected. Designed by Rafael Viñoly, it is horseshoe-shaped—as was the former structure. The outside wall resembles a curved Roman aqueduct and is actually a building itself, housing the press box, classrooms, and concession stands. The field and lower tier of seats are sunken in a bowl while the second deck is above grade and floats between the lower bowl and the outside building.

The photo shows one of Ruffin Hobbs' topiary tigers at the stadium entrance. Sans ivy, the two stainless steel tigers seem especially fierce!

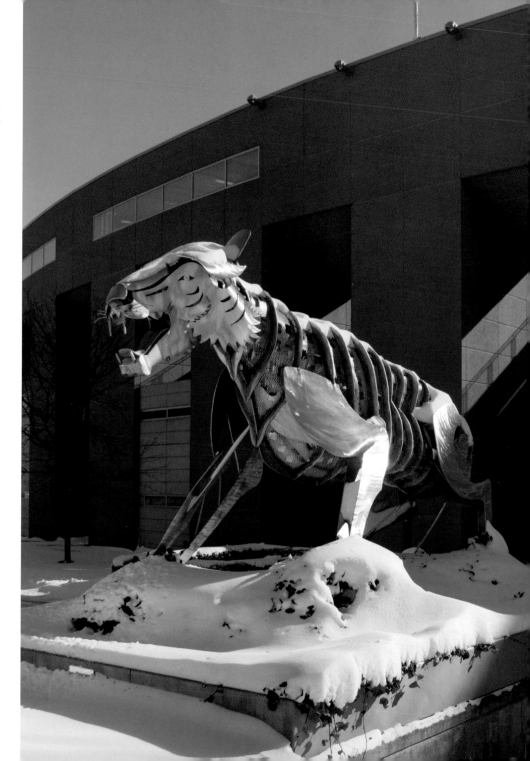

Pair of topiary tigers, 2000, by Ruffin Hobbs.
Princeton Stadium, Princeton University

Lewis Library

Princeton is inextricably linked to the Gothic tradition, and yet this style still generates controversy: Should the school continue to build in a medieval style in modern times? Do new buildings have to fit in with the old? Will Princeton still be Princeton if the modern campus continues to grow?

In 2004 the tension between nostalgia and innovation came to a head when the university began construction on two very different buildings simultaneously: neo-Gothic Whitman College, seen later on this walk, and the Lewis Library, named for Peter B. Lewis, Class of 1955, former chairman and CEO of Progressive Insurance. The library was designed by renowned postmodernist architect Frank Gehry, famous for such buildings as the Guggenheim Museum in Bilbao and the Louis Vuitton Foundation in Paris, and seems sculpture-like with its curved roofs of steel, sheer glass walls, and vibrant colors. A screen of trees helps integrate this ultra-modern building into the more traditional campus.

## Frick Chemistry Laboratory

This new chemistry laboratory was the largest academic building on campus, excluding Firestone Library, when it was completed in 2010. A stunning glass structure with a huge atrium spanned by pedestrian bridges, it represents the collaboration between Hopkins Architects of London and Payette Associates of Boston.

Princeton Professor Edward Taylor inadvertently made this state-of-the-art building possible: he discovered a compound that could be used in chemotherapy and cooperated with Eli Lilly and Co. to develop the anti-cancer drug pemetrexed (Alimta). The university's share in the royalties funded the construction of the laboratory.

The aptly named CaFe is in the south atrium, offering both indoor and outdoor seating.

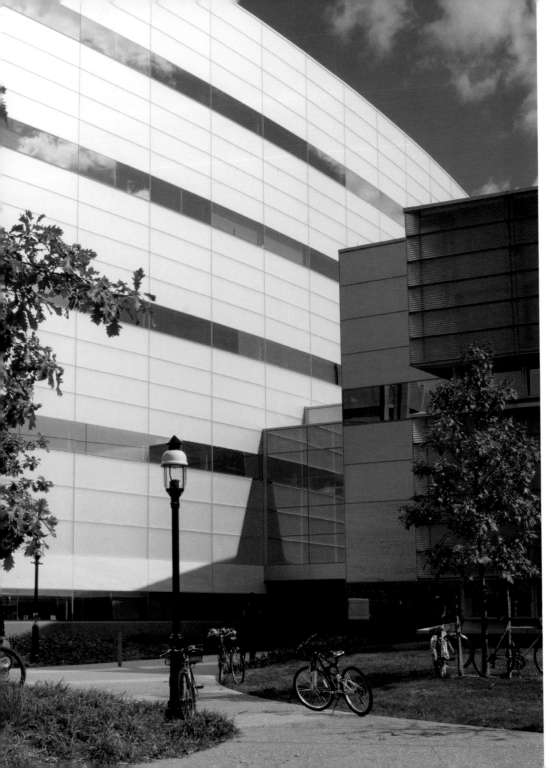

## Princeton Neuroscience Institute and Peretsman Scully Hall

This luminous 2013 complex houses the Princeton Neuroscience Institute. The focus of the design by award-winning architect José Rafael Moneo in collaboration with Davis Brody Bond is on natural light, which filters through the glass walls and penetrates deep into the building via light shafts.

The Neuroscience Institute was created in 2005, bringing together experts from many fields to better understand the functioning of the brain as a whole, and, in the process, shed light on disorders and illnesses such as autism and Alzheimer's disease. President Tilghman (2001–13), who helped pave the way for the new institute and building, declared neuroscience "one of the most exciting frontiers of human understanding right now." (*Princeton Weekly Bulletin* [*PWB*], Nov 21, 2005). The Department of Psychology is in the taller building on the left, Peretsman Scully Hall.

## Carl Icahn Laboratory

The Carl Icahn Laboratory is the home of the Lewis-Sigler Institute for Integrative Genomics, which aims to examine different genes and their roles in a variety of organisms. The institute was founded by former university president Shirley Tilghman, a molecular biologist, and it is thus fitting that the newly created Tilghman Walk begins here, leading west to the Lewis Center for the Arts.

The laboratory was completed in 2002 and was Rafael Viñoly's second project at the university. Its most impressive features are, of course, the huge atrium with its southwestern wall of glass and the series of aluminum louvers that shade the building and walkway, rotating with the movement of the sun. Depending on the time of day, the light throws interesting patterns across the walkway that vaguely resemble DNA, and pedestrians are reflected endlessly on the glass panels of the wall.

The building itself was donated by investor Carl Icahn, Class of 1957, while the institute was founded with the help of a gift by Peter B. Lewis, who honored his friend and Princeton roommate Paul B. Sigler, Class of 1955, a noted structural biologist.

## Scully Hall

The Scully Hall dormitory was designed by Rodolfo Machado. The building makes subtle references to the neo-Gothic structures on the old part of campus: narrow windows, an arch, tinted concrete to evoke slate. In contrast to the dormitories of old, however, Scully Hall no longer features characteristic "entries," which were introduced in the early nineteenth-century. For a century, dormitories had been built in vertical segments or entries, thus resembling a set of townhouses, each with its own front door facing a central courtyard. This design was intended both to reduce the risk of fire and to prevent students from indulging in a popular prank: rolling hot cannonballs down long hallways. In today's dormitories, corridors are back in style—perhaps because students no longer have access to cannonballs.

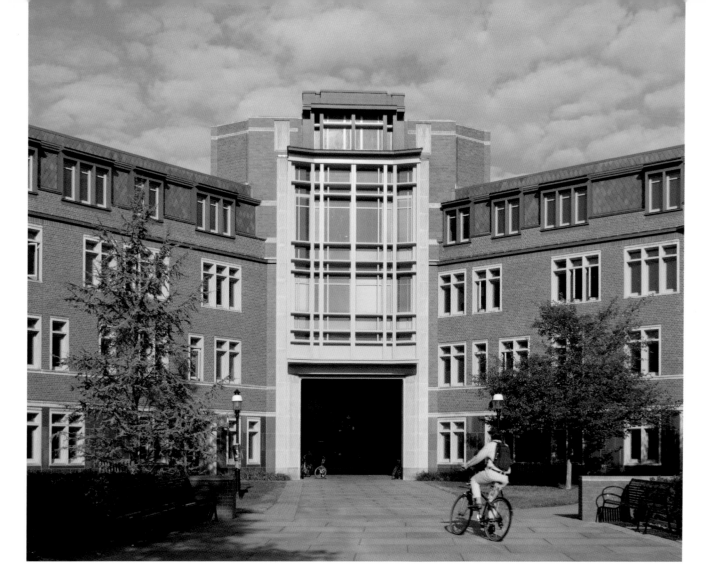

## Bloomberg Hall

Each year tens of thousands of students, alumni, and their families walk through the arch of Bloomberg Hall for the finale of the annual procession known as the "P-rade," a highlight of reunions weekend. Glancing up at the ceiling, they cannot miss the colorful composition by Sol LeWitt, *Wall Drawing #1134, Whirls and Twirls (Princeton)*, the first painting in the outdoor campus art collection.

This second dormitory on the edge of Poe Field was named for Emma Bloomberg, Class of 2001, daughter of the financier and former New York City Mayor Michael Bloomberg. As part of the university's efforts to grow sustainably, the building, designed by Michael Dennis, includes such features as bamboo flooring, triple-glazed windows, and a white roof.

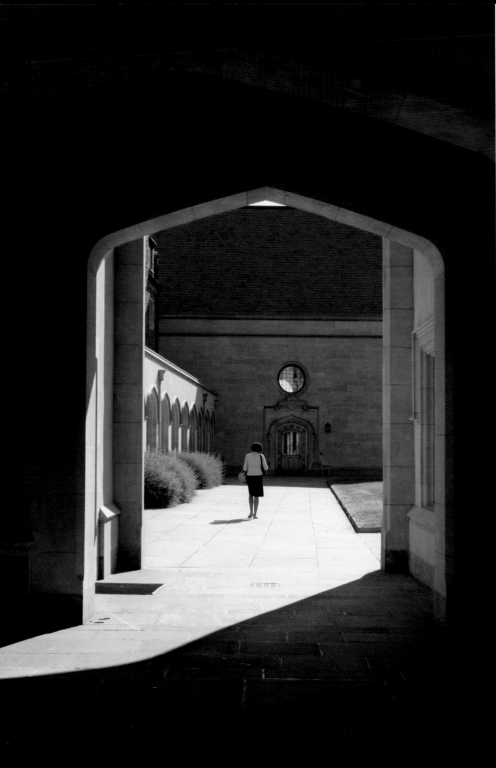

## Whitman College

Inaugurated in 2007, Whitman College is named after Meg Whitman, former president and CEO of eBay. An alumna of the Class of 1977 and former trustee, she graduated in one of the first co-ed classes. Coeducation was not readily embraced by Princeton, but by 1969 it was becoming clear that the all-male environment was putting the school at a disadvantage in attracting the best students. In spite of fierce opposition by older alumni, the policy was changed, and the first female undergraduates started in the fall of 1969.

Whitman College was the first new Collegiate Gothic complex to be built since the 1950s as this building style had become prohibitively expensive. Over the years, traditionalist alumni had issued repeated calls for a return to the university's favorite architectural style. Whitman's donation, along with gifts from more than thirty other donors, helped fulfill the alumni's dream: architect Demetri Porphyrios, who had also designed neo-Gothic buildings in Cambridge and Oxford, conceived Whitman College with its tower, cloister, and stone masonry walls.

## Transit Plaza and Arts Neighborhood

The location of the Princeton train station has long been a hot topic. When the railroad company decided to move the station from the end of Canal Street (today Alexander Street) to Princeton Junction, residents protested vehemently and a commuter train line was built—the shortest in the US. The Dinky or "PJ&B" (Princeton Junction and Back) originally ran to the foot of Blair Hall. The end of the line has been moved south several times since then, most recently another 460 feet. The modern transit plaza, which also features a convenience store, is now located in the university's newly conceived Arts Neighborhood. This area, anchored by the popular McCarter Theatre Center, is home to the Lewis Center for the Arts and offers several additional performance venues. Other attractions include an art gallery as well as a café and restaurant with outdoor seating.

Princeton train station in the foreground; new Lewis Center for the Arts (still under construction) in the background

Wu Hall

Woodrow Wilson had first introduced, but failed to implement, the idea of establishing residential colleges as a way to reinforce a sense of community on campus. Almost eighty years later, it was President Bowen who inaugurated the first residential colleges for freshmen and sophomores. Wu Hall, the dining and social center of the newly devised Butler College, was designed by Robert Venturi, Class of 1947, and his wife and fellow architect Denise Scott Brown, and completed in 1983. A modern edifice, Wu Hall subtly references neighboring buildings and evokes the neo-Gothic tradition on campus with its decorations of architectural symbols. This "Venturi-style" became, for a time, very influential at Princeton and can be seen in a number of other modern facilities on campus.

Wu Hall is named after Sir Gordon Wu, who graduated in 1958, a time when Princeton was still mainly male, white, and Christian. Diversity only increased when the university promoted Carl A. Fields to assistant dean of the college in 1968. The first African American to hold such a leadership position in the Ivy League, Fields introduced new policies and programs to enroll and retain more minority students.

## Butler College

In 2007 the university introduced four-year colleges, for the first time allowing undergraduates from all four classes and graduate students to live and dine together. In the process a whole new set of dormitories was built for Butler College, right across from Venturi's Wu Hall.

The complex was designed by Henry Cobb of Pei, Cobb, Freed and Partners and evokes the picturesque richness of the neo-Gothic quadrangles of the historic parts of campus with its smaller buildings of different heights, courtyards, and walkways. The flat walls are broken up by playful undulations, which allow for larger bedrooms.

Butler Memorial Court (pictured) is a landscaped amphitheater enclosed by three dormitories. Not visible to the casual passerby are the green roofs planted with a variety of sedum. They were installed on more than half of the total roof area to reduce energy needs and stormwater runoff. Fitted with sensors, they also provide an opportunity to study the effects of green roofs.

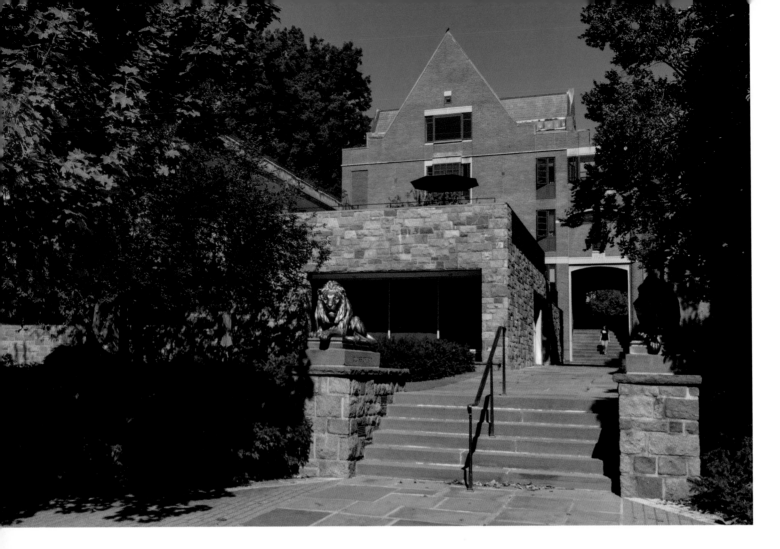

Pair of Lions near Wilcox Hall

Lounging in the foreground are a pair of gilt lions presented by the Class of 1879 at their tenth reunion and originally installed in front of Nassau Hall. By the beginning of the twentieth century, however, the tiger had firmly taken hold as the university's mascot, and the lions had to move out, first to 1879 Hall and later, after being damaged, to storage. Unearthed many years later and restored, they now grace the entrance to Wilson College, quite fittingly as Woodrow Wilson was a member of the Class of 1879.

Pair of lions, before 1889. Cast by J. L. Mott Ironworks, A. Schiffelman. Wilcox Hall, Princeton University

## Frist Campus Center

Over the years there had been repeated calls for a campus center: a central communal space for students, staff, and faculty. At last, in 2000, the Frist Campus Center, named for the Frist family, was opened. In a striking combination of old and new, the architecture firm Venturi Scott Brown used the existing Palmer Laboratory and, leaving the façade, inserted a major addition into the former courtyard.

Looking closely at the arcade in front of the building, you will notice a series of irregular bumps on the top: Venturi had originally wanted the arcade to spell "Frist Campus Center." The town, however, viewed the arcade as an oversized sign and therefore in violation of local zoning rules. University and architects thus opted to alter the design and left only the top few inches of each letter.

Frist has become a nexus where students get their mail and all members of the university community come together for snacks, classes, meetings, theater performances, and many other activities. A listing of public events held at the campus center can be found on the university's online events calendar.

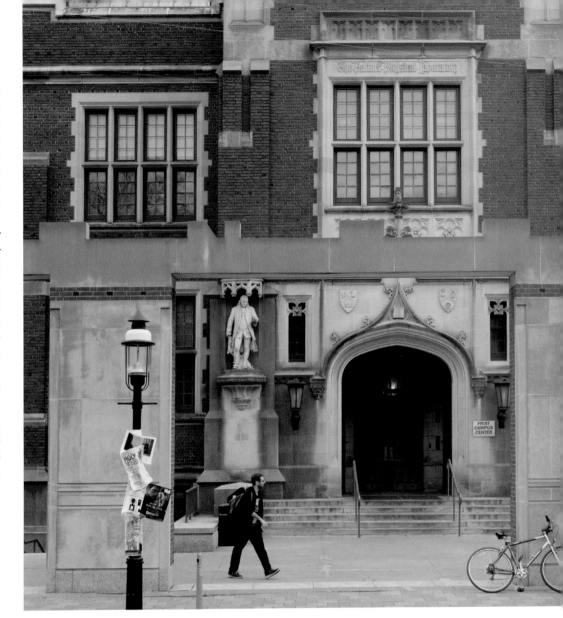

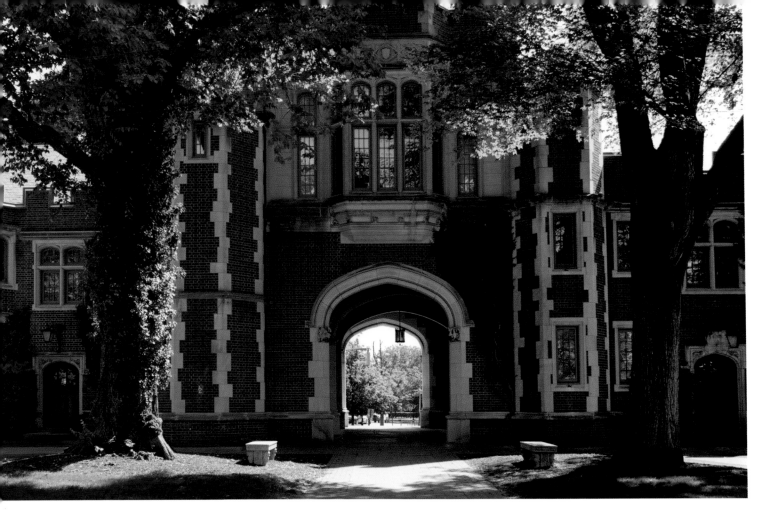

## 1879 Hall

While this walk has focused on the newest buildings on campus, we now arrive at 1879 Hall, having circled back a century to the beginning of the Collegiate Gothic period on campus. Like Blair Hall, 1879 Hall was designed as a wall dormitory—long and narrow, separating the campus from the outside world. It is especially rich in ornamentation, boasting sixty grotesques—the more common word "gargoyle" really only refers to waterspouts—crafted by Gutzon Borglum (who later went on to carve Mount Rushmore).

When 1879 Hall was completed in 1904, then-university president Woodrow Wilson moved his office into the tower room above the vaulted archway leading to Prospect Avenue. It is a poignant image: Wilson, at the end of his administration, standing at the window and gazing out at the eating clubs he was vainly trying to banish.

## Prospect Avenue

The eating clubs are a thoroughly Princetonian tradition. Faced with bad food and the eventual closing of the school's refectory in 1856, students took matters into their own hands and founded eating clubs. Over time and in the absence of fraternities, the clubs became the center of social life for the upper-class students. By the beginning of the twentieth century, "The Street" (Prospect Avenue) was lined with imposing club houses built with the support of wealthy alumni in the favorite revival styles of the times. (Charter Club is pictured.)

Woodrow Wilson was the first president of the university to try to abolish the clubs, as he thought they undermined the "democratic spirit" of Princeton, due to their exclusive nature (Axtell 2006, 16). In some years more than thirty percent of all students were not accepted by any of the clubs; these so-called "sad birds" became social outsiders. Although Wilson failed in his effort, protests against the clubs increased in the ensuing decades, and additional dining options were eventually introduced and expanded.

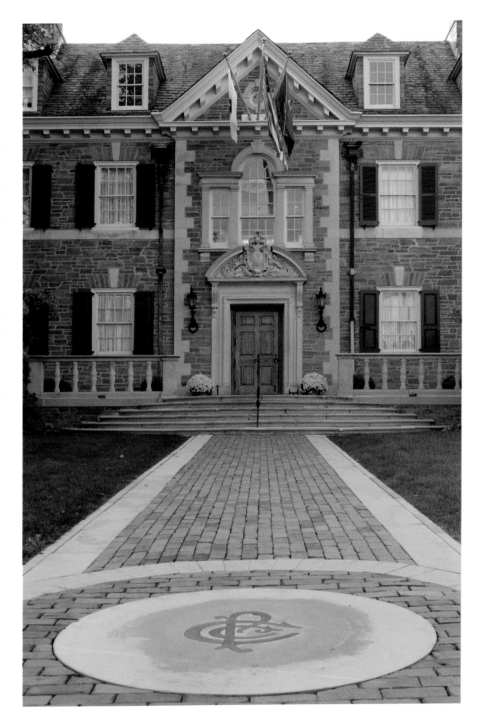

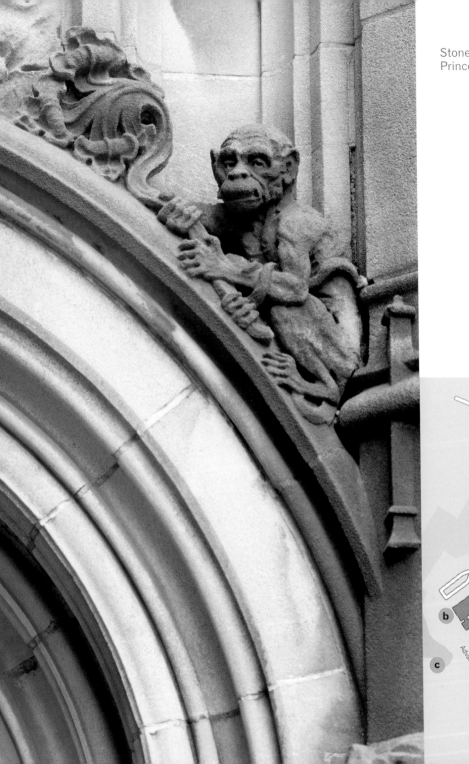

Stone detail at the Graduate College,
Princeton University

# WALK FIVE: From Seminary to Institute

On our final walk we explore the university's far-flung Graduate College—the neo-Gothic residential complex built to house students of the Graduate School in the early twentieth century. We will also pay homage to two other venerable educational institutions: a renowned seminary and a historic think tank.

1. Princeton Theological Seminary
   a. Alexander Hall
   b. Miller Chapel
   c. Stuart Hall
   d. Library
2. Springdale Golf Club
3. Graduate College
   a. Central Quadrangle
   b. Dean's Garden
   c. Cleveland Tower
4. Institute for Advanced Study
   a. Fuld Hall
   b. Historical Studies-
      Social Science Library
   c. Institute Woods

There is parking on Mercer Street and in a municipal lot behind Trinity Church; parking is also available in the residential areas adjacent to the seminary library.

To get from the seminary to the Graduate College, proceed through the seminary campus and exit between Brown Hall and Mackay Campus Center onto College Road.

As this is a longer walk, you might want to consider packing a snack for a little picnic at the institute pond.

Mapbox
© Mapbox, © OpenStreetMap

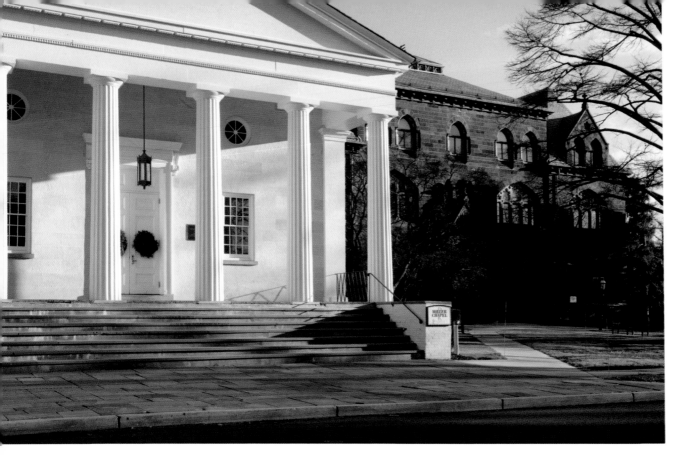

Miller Chapel with Stuart Hall in the background

## Princeton Theological Seminary

The Princeton Theological Seminary (PTS) was founded in the early 1800s, a time of tremendous growth in the new American nation. The need for clergy was rapidly increasing as East Coast cities swelled in population, and large numbers of settlers moved westward to establish new towns. At the same time interest in overseas missionary work was burgeoning. The old system of preparing clergy through college, followed by one-on-one apprenticeships with senior ministers, was proving inadequate in meeting the demand.

Three powerful church leaders—Ashbel Green and Samuel Miller, both trustees of the College of New Jersey, and theologian Archibald Alexander—began calling for a new graduate theological institution separate from the college. They envisioned a school where students from all over the country could gather and be instructed by the church's most competent teachers. In 1812, after four years of study and planning, the General Assembly of the Presbyterian Church established PTS. Although the seminary and the college were independent institutions, they maintained exceptionally close ties until the end of the nineteenth century: in one such example Ashbel Green simultaneously served as president of the college and as president of the seminary's board of directors.

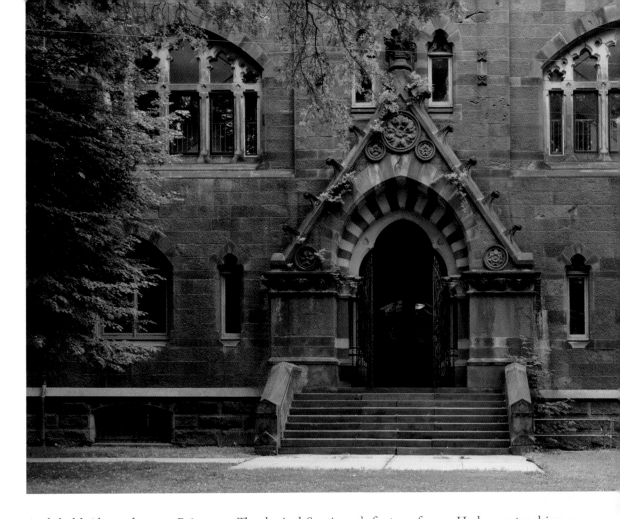

Archibald Alexander was Princeton Theological Seminary's first professor. He began teaching a handful of students in his own home, but the student body soon outgrew this space. The college provided classrooms in Nassau Hall until the seminary could complete its own building in 1817. Today that building is called Alexander Hall in honor of the first professor. Samuel Miller, after whom the Steadman-designed Miller Chapel was named, became the seminary's second professor. For almost four decades, these two theologians indelibly shaped the newly founded school, which quickly grew to over 100 students.

In 1876 the seminary erected its first dedicated classroom building, Stuart Hall (pictured). The latter was donated by brothers Alexander and Robert L. Stuart, strict Presbyterians and generous donors to the seminary, who made their fortune refining sugar in New York. Designed by William Appleton Potter in the Venetian Gothic style, Stuart Hall is still used for classroom instruction. The fine details on the entrance reflect the fact that this was originally intended to be the campus' main gateway.

PTS is regarded as one of the leading theological schools in the United States. While it has been under the care of the Presbyterian church throughout its history, from the very beginning PTS accepted students from other denominations. In the twentieth century presidents J. Ross Stevenson, John A. Mackay, and James McCord were leaders in the ecumenical movement of the time. Today the seminary's faculty and student body represent a wide range of Protestant denominations as well as Roman Catholic and Eastern Orthodox faiths.

The PTS Library was constructed in 2013 and is one of the most extensive seminary libraries in North America. The new edifice is undeniably modern but also evocative of the Gothic tradition in Princeton, and features salvaged materials from the former libraries such as the medallions on the façade. Comfortable armchairs and a well-lit café are located just inside the entrance.

Princeton Theological Seminary Library

## Springdale Golf Club

The Springdale Golf Club and Princeton University Graduate College are located on the grounds of the old 240-acre Stockton Farm. Princeton alumni Moses Taylor Pyne, Stephen Palmer, and Cornelius C. Cuyler helped raise the funds to buy the farm in 1899 as a site for the Princeton Golf Club, later renamed Springdale Golf Club. Once snow has fallen, families and students flock to the low hills of the links, a favorite sledding site.

Forbes College, Princeton University, as seen from Springdale Golf Club

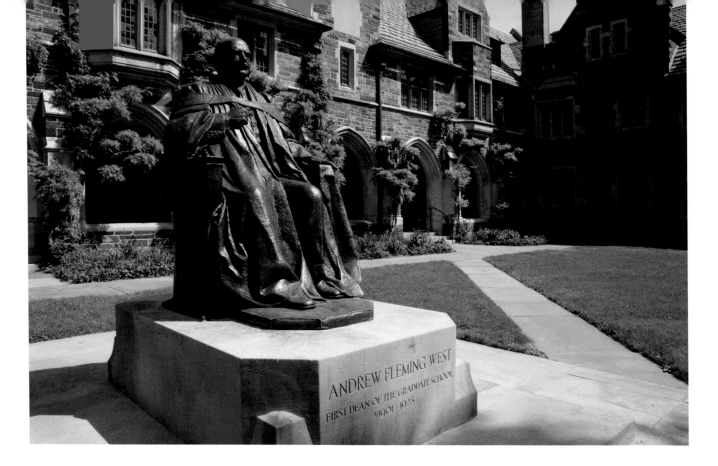

## Graduate College

Graduate education has a long history at Princeton University. Even in the eighteenth century, James Madison remained at Princeton after receiving his degree to take additional courses under Rev. Witherspoon's guidance. But it was President McCosh who first referred to the College of New Jersey as a university in his inaugural address in 1868 and created the first formal programs leading to advanced degrees. In 1896 at its sesquicentennial, the College of New Jersey officially became "Princeton University"; that is, a school offering graduate degrees.

The location of the Graduate College (namely, the living and dining quarters for graduate students) soon became a matter of considerable controversy. Woodrow Wilson, then president of the university, envisioned graduate education as central to the university and wanted to build a new graduate complex close to the center of campus.

*Andrew Fleming West, Class of 1874 (1853–1943)*, before 1928, by Robert Tait McKenzie. Central quadrangle of the Graduate College

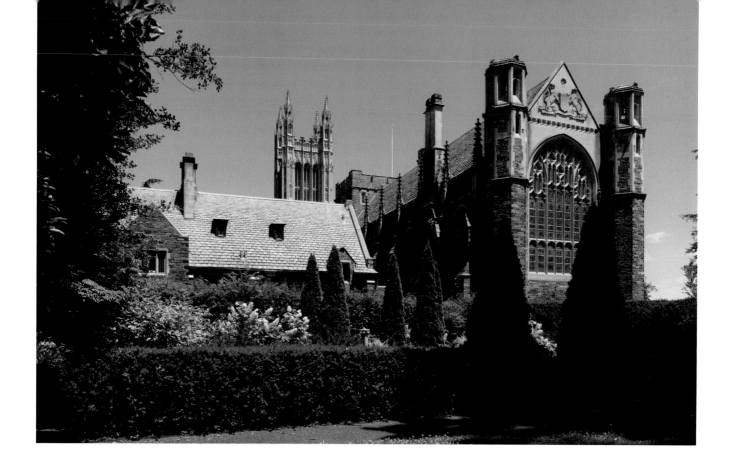

Andrew Fleming West, the first dean of the Graduate School, aimed for a quiet location away from the undergraduate hustle and bustle. After a bitter struggle Wilson conceded defeat, and the new residential Graduate College was built on the serene Springdale Golf links. This provided Dean West and architect Ralph Adams Cram with the ideal opportunity to build a complete neo-Gothic complex unfettered by existing buildings.

A small arch next to Cleveland Tower leads to the central and oldest quadrangle. Landscaped by Beatrix Farrand, this quiet haven is dominated by two evergreens, rare cedars of Lebanon, and a cloister with espaliered wisteria climbing the wall, her signature plant treatment. She also laid out the Dean's Garden behind Wyman House.

Procter Hall is the formal dining hall of the Graduate College—a church-like setting complete with a hammer beam roof, immense stained glass windows, and an organ. For decades, in a tradition that brings Harry Potter to mind, the graduate students wore gowns to dinner, and a select group of faculty and students dined at a high table.

Dean's Garden behind Procter Hall and Wyman House

Former President Grover Cleveland made Princeton his home in the late 1890s. A trustee of the school and good friend of Dean West—Cleveland called his own home "Westland"—he was deeply involved in the planning of the Graduate School. After his death in 1908, a public subscription, what we call crowdfunding today, was started to help build the 173-foot-high Cleveland Tower as a memorial. Designed by Cram, the tower features hexagonal turrets at its corners, which grow progressively narrower and more ornate as they rise to the sky.

The tower contains a carillon, a musical instrument composed of bells dating to sixteenth-century Europe. The original Cleveland Tower carillon was a gift from the Class of 1892 and consisted of thirty-five bells cast in England. Over the years it was expanded and modified several times. In the 1990s, during a significant renovation, a new four-ton B-flat bass bell, the Ettl Bell, was added; the instrument, which now contains sixty-seven bells, was placed in concert pitch. The Princeton University Carillon is generally played on Sunday afternoons. There is also a summer concert series featuring carillonneurs from around the world.

Cleveland Tower as seen from Springdale Golf Club

## Institute for Advanced Study

The Institute for Advanced Study (IAS) is about a mile from downtown Princeton, tucked away between a serene neighborhood and the expansive Institute Woods. This center for postdoctoral research is not affiliated with Princeton University, but the two institutions have always collaborated closely.

IAS was founded in 1930 by philanthropists Louis Bamberger and his sister Caroline Bamberger Fuld, guided by educator Abraham Flexner. Flexner, who became the founding director, sought to create a place where scholars could indulge their curiosity and dedicate themselves to pure research, a mission that remains unchanged even today. The institute has four schools: Historical Studies, Mathematics, Natural Sciences, and Social Science. Each year about 200 scholars from all over the world, called "members," are given a fellowship to work, study and live in this "academic village."

Fuld Hall, first building constructed for the institute, completed in 1939

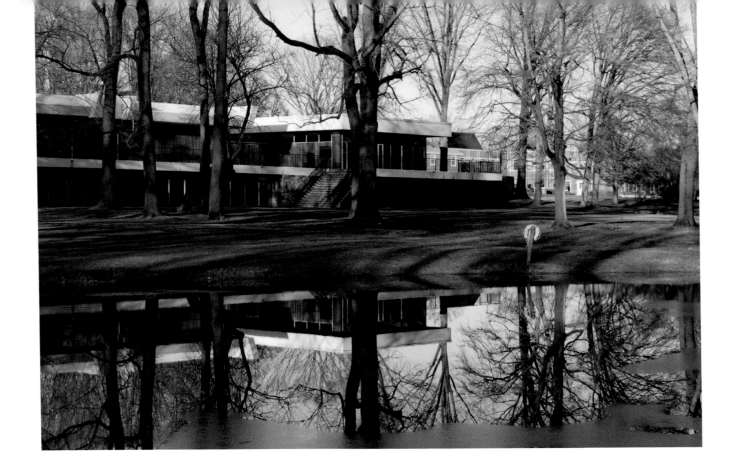

Oswald Veblen and Albert Einstein were the first two professors at the School of Mathematics, founded in 1933. Having attracted such stars, the school quickly gained prominence and became a mecca for mathematics, recruiting elite scholars from all over the world and helping many intellectuals escape the Nazi regime. Some of the famous academics on the faculty in the early years were Hermann Weyl, Kurt Gödel, and J. Robert Oppenheimer, the latter serving as director of IAS from 1947–66. Contrary to common practice at the time, the institute also accepted women both as members and as professors: algebraist Emmy Noether and topologist Anna Stafford were part of the first group of members invited to the IAS and in 1936 archaeologist Hetty Goldman was the first woman to join the faculty.

As Flexner had hoped, major discoveries have been made at the IAS over the years. One of the first achievements and certainly one that has changed the world was John von Neumann's "IAS machine," a modern computer. The machine was then promptly used to develop the first meteorological models for weather prediction.

Historical Studies-Social Science Library, designed by
Wallace K. Harrison and completed in 1965

The institute was originally established on the 200-acre Olden Farm, then slowly expanded to encompass 800 acres. In 1997 almost 590 acres of woods, farmland, and a broad floodplain along the Stony Brook were permanently conserved, providing a needed haven for wildlife and birds. The "Institute Woods" begin behind the little pond, which is graced by sculpted granite benches by Elyn Zimmerman, at the southern end of campus. Open to the public, this popular green space is beloved by bird-watchers, walkers, runners, and cross-country skiers alike. A network of trails connects the woods to Battlefield Park, Clarke House, and Princeton Friends Meetinghouse. Spring is an especially lovely time to take the Founder's Walk to the Swinging Bridge over the Stony Brook. From here you can stroll over to the Charles H. Rogers Wildlife Refuge, which features observation platforms with a view over the marsh—ideal for birders. Public parking for the Institute Woods is available at Battlefield Park.

The Institute Woods

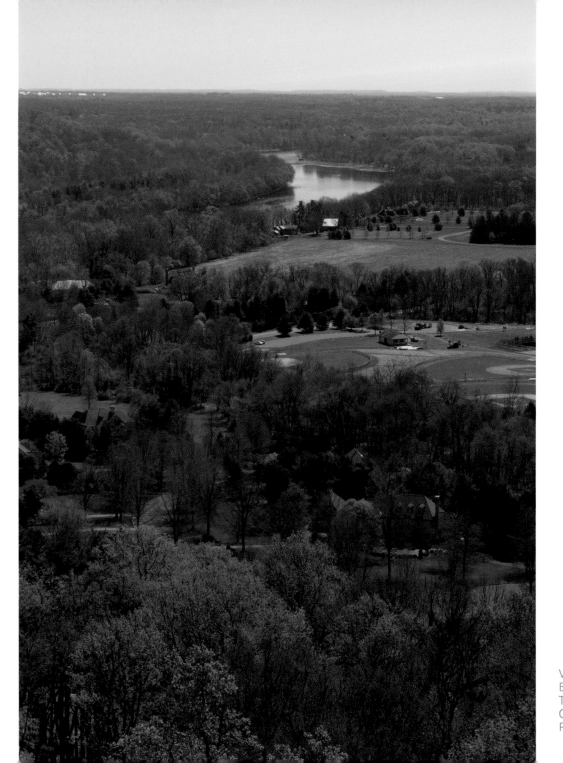

View from
Bowman's Hill
Tower, Washington
Crossing Historic
Park, Pennsylvania

# Attractions in
## Princeton and Beyond

The greater Princeton area boasts a wealth of theaters and museums, parks and gardens. Some of these attractions are featured in the preceding walks; many more lie further afield. In this chapter we provide an overview of some of the area's most compelling sites, both in town and beyond (within an hour's drive), so that longtime residents, new arrivals, and day trippers alike can more fully explore local offerings. This section is structured by interest for easy reference.

History

Nature and Gardens

The Arts

Hiking, Biking, and More

Local Food

The Sciences

Within each of these categories a few select attractions are featured in detail, followed by more complete lists.

Glimpse of the grounds at Pennsbury Manor, Morrisville, Pennsylvania

# History

Lovers of history will discover landmarks at nearly every turn, as central New Jersey is chock-full of old cemeteries, battlefields, monuments, and historic house museums. We have highlighted a few favorite sites in Princeton as well as some lesser-known spots, and included suggestions for longer outings. Many of these attractions also offer other amenities such as gardens, hiking trails, and picnic areas.

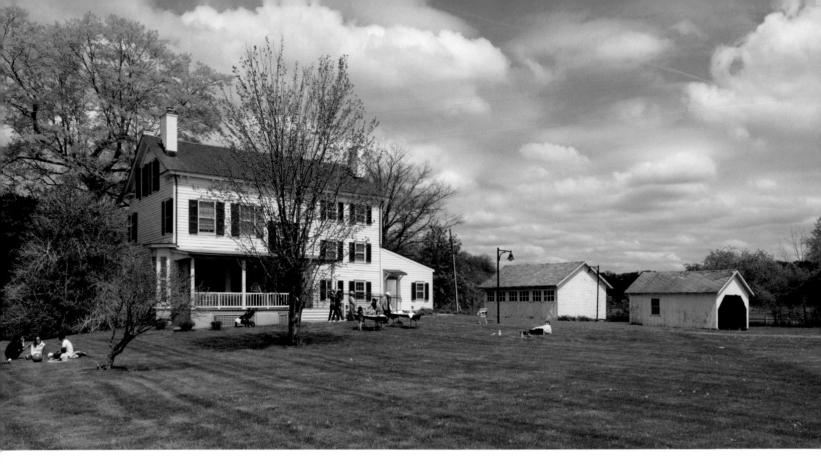

## Historical Society of Princeton at Updike Farmstead, Princeton

Since 2016 the Historical Society of Princeton (HSP) has been headquartered at the Updike Farmstead. Founded in 1938 to preserve and celebrate Princeton's history, HSP has amassed a significant collection of photographs, printed materials, and artifacts, many of which can be viewed in changing exhibitions at the farmstead. Visitors may also enjoy a permanent exhibit on beloved local scientist Albert Einstein and other New Jersey innovators. HSP offers educational programs for both adults and children, including Sunday walking tours of downtown Princeton as well as "The Albert E. Hinds Memorial Walking Tour: African American Life in Princeton," available by appointment or as a digital tour.

The Updike Farmstead once belonged to a vast 1,200-acre tract of land owned by Benjamin Clarke, an early Stony Brook settler, and was a working farm for over three centuries. The Updike family owned and operated the farm throughout the twentieth century; their windmill still turns in the backyard, evoking a more rural past. The image shows the late eighteenth/early nineteenth-century farmhouse.

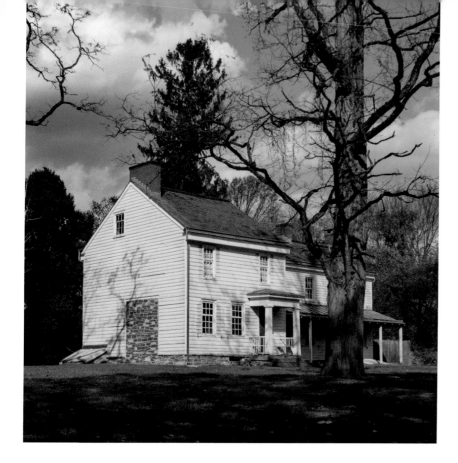

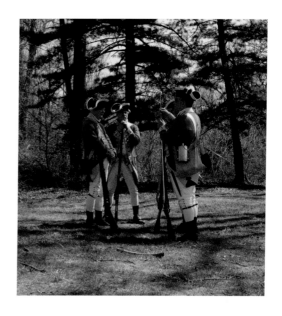

Princeton Battlefield State Park, Clarke House, and Princeton Friends Meetinghouse, Princeton

One of Princeton's most richly historic areas can be found southwest of town along Mercer Road. The Battle of Princeton, a decisive battle of the American Revolution, was waged here on January 3, 1777, one week after General Washington famously crossed the Delaware River. During a skirmish General Hugh Mercer, for whom Mercer County is named, was bayoneted; according to legend, the mortally wounded general lay under a white oak tree, then was transported to Clarke House, the nearby farmhouse, where he died nine days later. The white oak grew into the mighty Mercer Oak that dominated the battlefield until the year 2000; a descendant of the original oak, seeded from an acorn in 1981, graces the park today.

Living history military demonstrations take place in the park several times a year. The Thomas Clarke House museum is open year-round and also offers special programs focusing on colonial life.

The Princeton Battlefield State Park provides easy access to the Institute Woods and Princeton Friends Meetinghouse, a historic Quaker house of worship with its own little cemetery nearby.

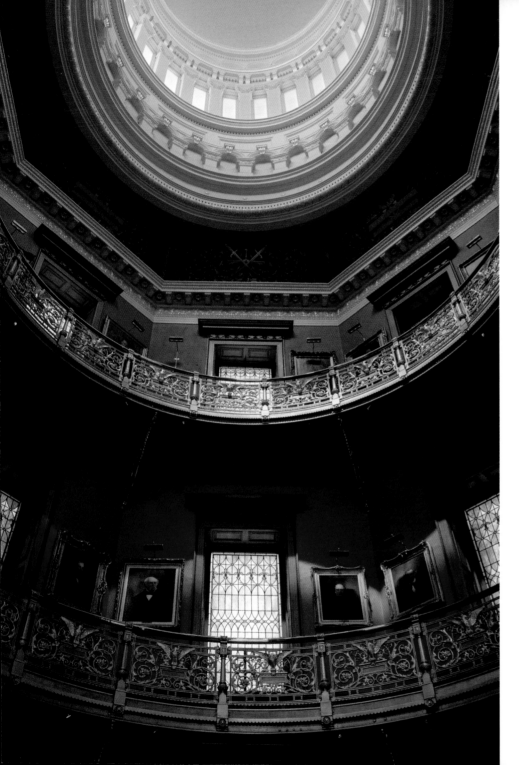

## New Jersey State House, Trenton

With its bright golden dome, the New Jersey capitol building on the banks of the Delaware can be seen from far and wide. One of the oldest in the country, the original state house was built in 1792 but has been expanded and renovated numerous times. Philadelphia architect John Notman, whose work can also be seen in Princeton, designed the domed rotunda in 1845 to connect the historic building to its first major addition. Today's dome, which rises to an impressive 145 feet, was built after a devastating fire raged through the building in 1885.

The New Jersey State House is home to both the governor's office and the legislative branch of government. Guided tours are available and usually include the rotunda (pictured), the assembly chamber with its giant chandelier installed by Thomas Edison's company, and the senate chamber.

Other attractions within walking distance include the Old Barracks Museum and the New Jersey State Museum.

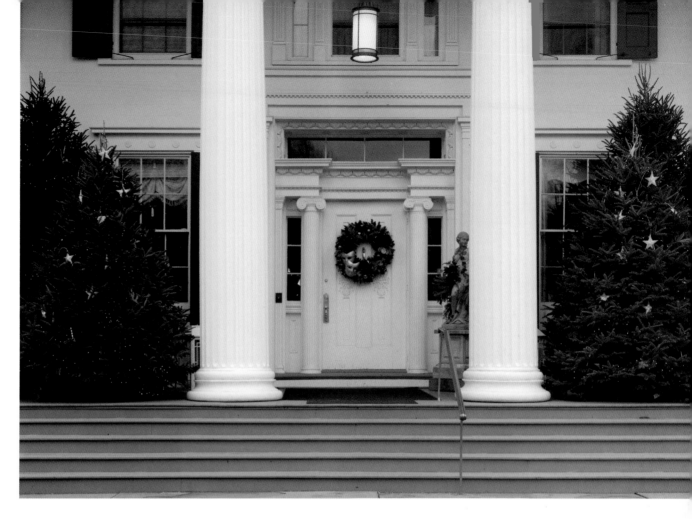

Drumthwacket, Princeton

This storied house has had many illustrious inhabitants. Drumthwacket was built in 1835 by wealthy businessman Charles Smith Olden, who became the first New Jersey governor to reside here. University benefactor Moses Taylor Pyne bought the property in 1893 and turned it into an estate. He significantly expanded the house, adding two wings and an elaborately landscaped park with a formal Italianate garden. In 1941 Abram Nathaniel Spanel, a scientist and founder of the International Latex Corporation, purchased the house and did much of his inventing in what is now known as the Music Room. After extensive renovations, Drumthwacket then became the official governor's residence in 1981.

Drumthwacket is open to the public most Wednesdays for guided tours of the downstairs, which includes an expansive dining room and a library with a carved stone fireplace. The upstairs is reserved for the current governor and family. The gardens are also open to the public on these designated days. Additional open houses are held in December when the house is decorated for the holidays.

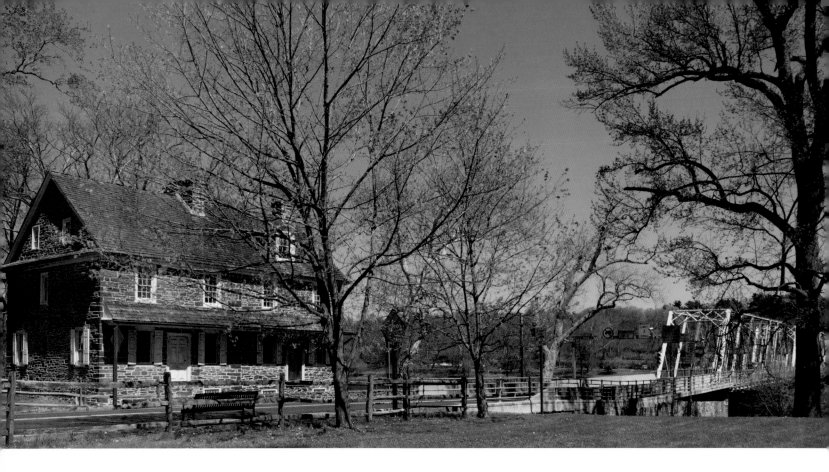

## Parks at Washington Crossing, Pennsylvania and New Jersey

Two similarly named parks can be found along the Delaware where George Washington crossed the river on the eve of his important victory at Trenton: The Washington Crossing State Park in New Jersey and the Washington Crossing Historic Park in Pennsylvania.

Some of the attractions at the 3,500-acre New Jersey park include trails for hiking, biking, and horseback riding; a nature center; the historic Johnson Ferry House; and the Visitor Center Museum, which illumines the "Ten Crucial Days" between December 25, 1776 and January 3, 1777. In summer there are regular theater performances at the park's open air theater.

The Pennsylvania park features a historic village with an inn (pictured), store, post office, and several homes; guided tours are available. The Thompson Neely Farmstead and Mill and the 125-foot Bowman's Hill Tower are farther upriver; the tower affords an expansive view of the Delaware River and the countryside.

Both parks draw hundreds of visitors on Christmas Day when re-enactors in Continental military dress cross the Delaware from Pennsylvania to New Jersey in replica Durham boats.

Howell Living History Farm, Lambertville

Part open-air museum and part working farm, Howell brings the history of farming alive through a spate of hands-on programs. Farmers have lived on and worked this land since the 1730s; the last owners were Charles and Inez Howell. The latter gave the farm to Mercer County as a gift in her husband's memory with the stipulation that the site be used to teach the public about farming.

Howell Living History Farm animates farming practices of the period between 1890 and 1910, critical decades that witnessed the introduction of the gasoline engine and new agricultural technologies. Visitors can stroll around the various outbuildings and visit the animals in their pens on most weekdays; on Saturdays there is more to see and do when farmers perform seasonal work: plowing the fields with a team of oxen, shearing sheep, harvesting corn, and maple sugaring. Many events are held throughout the year, such as 4-H festivals and holiday celebrations.

## Monmouth Battlefield Park, Manalapan

The park transports visitors back to 1778 when one of the largest battles of the American Revolution, the Battle of Monmouth, was fought on this hilly ground in the heat of the summer. The park's visitor center is on Combs Hill, where the Continental Artillery once stood, and offers exhibits on the battle including an animated relief map illustrating the maneuvers.

A series of trails and farm roads, dotted with helpful exhibits on the battle, criss-crosses the orchards and fields, enabling visitors to imagine where the battle was fought and follow in the footsteps of the troops. A reenactment of the Battle of Monmouth takes place annually at the end of June.

This rural landscape has been farmed since the early eighteenth century; even today parts of the park are under cultivation, as the fields of corn and soybeans and extensive orchards demonstrate. In fact, visitors may pick their own fruit at Battleview Orchards, around the corner from the state park entrance on Wemrock Road.

## Mercer Museum, Doylestown, PA

Mercer Museum was named after Henry Chapman Mercer (1856–1930), an archaeologist and tile maker. The Doylestown native created three unique buildings in close proximity, all poured out of concrete: his factory, the Moravian Pottery and Tile Works; his private home, Fonthill Castle; and the museum. An amateur historian and keen observer of the Industrial Revolution, Mercer began collecting artifacts of day-to-day life that were being discarded before his eyes. In 1916 he built Mercer Museum to house and display his enormous collection, which included everything from the smallest tools to stage coaches.

The Mercer Museum's vast array of quotidian objects is considered one of the most complete collections of its kind in America. The artifacts are displayed in small chambers by function, ranging from the tools to make wallpaper to those designed for fruit preservation. The museum also features changing exhibitions in its modern wing and offers a range of educational programs—even treasure hunts to keep the youngest visitors engaged.

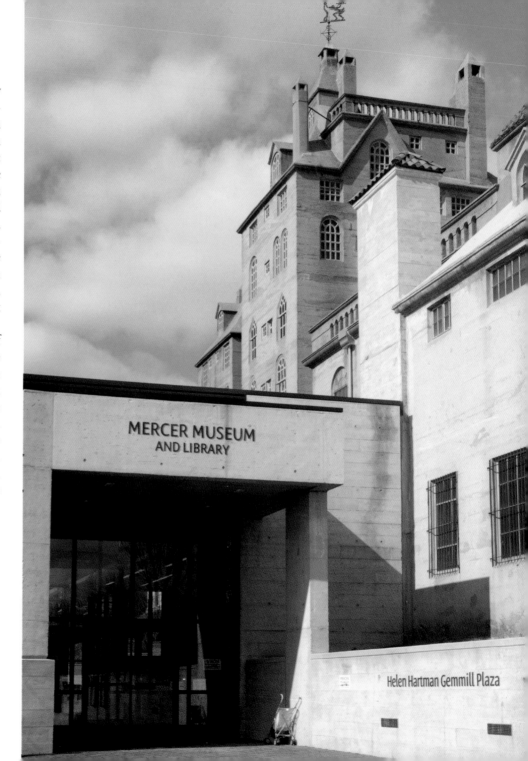

# Overview of Attractions - History

The area offers many opportunities to learn more about local history. Some sites listed below offer small glimpses into the past, a perfect little stop on the way; others are a destination in their own right.

### Princeton

| | | |
|---|---|---|
| Drumthwacket* | 354 Stockton Street, Princeton | Official residence of New Jersey's governor |
| Einstein Museum at Landau | 102 Nassau Street, Princeton | Shrine to Princeton's favorite scientist in a local woolens shop |
| Historical Society of Princeton* | 354 Quaker Road, Princeton | Princeton history museum in former farmstead, featuring permanent Einstein display and changing exhibits |
| Morven Museum and Garden* | 55 Stockton Street, Princeton | Museum in eighteenth-century Stockton family home, period rooms, galleries, garden |
| Princeton Battlefield State Park/ Clarke House/Princeton Friends Meetinghouse* | 500 Mercer Road, Princeton | Site of historic Battle of Princeton, revolutionary-era farm house, Princeton's first Quaker house of worship |

### Cranbury

| | | |
|---|---|---|
| Cranbury Museum | 4 Park Place East, Cranbury | Nineteenth-century house museum features changing exhibits on Cranbury's past |

### Doylestown, PA

| | | |
|---|---|---|
| Fonthill Castle | East Court Street and Route 313, Doylestown, PA | Castle made of poured concrete by nineteenth-century tile maker Henry Mercer; interior elaborately decorated with his tiles. Guided tours only |
| Mercer Museum* | 84 South Pine Street, Doylestown, PA | Extensive permanent displays of pre-industrial tools and artifacts; changing exhibits |
| Moravian Pottery and Tile Works | 130 East Swamp Road, Doylestown, PA | Working museum where tiles are still manufactured according to Henry Mercer's methods and designs |

### Hamilton

| | | |
|---|---|---|
| Civil War and Native American Museum, John Abbott II House | 2202 and 2200 Kuser Road, Hamilton | New Jersey's first museum dedicated to the Civil War. Eighteenth-century Abbott House (located next door) offers peek into colonial times |
| Kuser Farm Mansion | 390 Newkirk Avenue, Kuser Farm Park, Hamilton | Guided house tours of the Kuser family's former summer residence. Seasonal holiday programs in fall and winter |

### Hopewell

| | | |
|---|---|---|
| Hopewell Museum | 28 East Broad Street, Hopewell | Historic house offers glimpse into Hopewell's past via furnished rooms and ephemera |
| Princeton Doll and Toy Museum | 57 Hamilton Avenue, Hopewell | Museum filled with dolls and toys from all eras and around the world |

### Kingston

| | | |
|---|---|---|
| Rockingham Historic Site | 84 Laurel Avenue (Route 603), Kingston, Franklin Township | Historic house served as General George Washington's temporary headquarters during the Revolutionary War |

## Lambertville

| | | |
|---|---|---|
| Holcombe-Jimison Farmstead Museum | 1605 Daniel Bray Highway (Rte. 29), just north of Lambertville | Museum dedicated to agricultural heritage. Exhibits of farming tools; dentist's office, carpenter's shop, blacksmith shop, general store |
| Howell Living History Farm* | 70 Woodens Lane, Lambertville | Historic working farm and plein-air museum, seasonal farm activities |

## Manalapan

| | | |
|---|---|---|
| Monmouth Battlefield State Park* | 16 Business Route 33, Manalapan | Site of major Revolutionary War battle; walking trails, modern visitor center |

## Morristown

| | | |
|---|---|---|
| Morristown National Historical Park | Multi-site park at Morristown | Park commemorates Washington's winter encampment in 1779–'80. Hiking paths, restored farmhouse at Jockey Hollow; museum and Washington's headquarters in town; overlook at Fort Nonsense |

## Morrisville, PA

| | | |
|---|---|---|
| Pennsbury Manor | 400 Pennsbury Memorial Road, Morrisville, PA | Living history museum on William Penn's country estate on the Delaware; special events |

## New Hope, PA

| | | |
|---|---|---|
| New Hope & Ivyland Railroad | 32 West Bridge Street, New Hope, PA | Train ride from New Hope through Bucks County in vintage passenger coaches drawn by historic steam or diesel locomotives |

## Roebling

| | | |
|---|---|---|
| Roebling Museum | 100 Second Avenue, Roebling | Museum in the gatehouse of the former mill. Exhibits and film on Roebling family, company, and company town; stroll the historical Roebling village |

## Trenton

| | | |
|---|---|---|
| New Jersey State House* | 125 West State Street, Trenton | Historic capitol building housing New Jersey's executive and legislative branches |
| New Jersey State Museum | 205 West State Street, Trenton | Exhibits on New Jersey history from prehistoric to modern times |
| New Jersey State Police Museum and Learning Center | Located at NJ State Police Headquarters in West Trenton, on River Road between I-95 and West Upper Ferry Road | Displays on the history of the New Jersey State Police, their duties, tools, and methods |
| Old Barracks Museum | 101 Barrack Street, Trenton | Barracks and officers' house built during the eighteenth-century French and Indian War. Guided tours, gallery |
| Riverview Cemetery | 870 Centre Street, Trenton | Expansive historic garden cemetery on the bluffs above the Delaware |
| William Trent House Museum | 15 Market Street, Trenton | House museum and an extensive eighteenth-century kitchen garden |

## Washington Crossing, PA

| | | |
|---|---|---|
| Washington Crossing Historic Park* | 1112 River Road, Washington Crossing, PA | A two-part, 500-acre park featuring a historic village at the crossing and a tower further upriver |

Entries with an asterisk are described more fully elsewhere in the book; please see the index as needed.

# Nature and Gardens

Despite its famed density, the Garden State offers plenty of opportunities to enjoy nature. The greater Princeton area is home to many lovely gardens and dedicated green spaces, ideal for strolls of any length. Local nature preserves offer the chance to appreciate New Jersey's diverse native flora and fauna; most also feature nature centers and a variety of educational programs.

## Greenway Meadows Park, D&R Greenway Land Trust, Princeton

The best way to explore the fifty-five-acre Greenway Meadows Park may be the Scott and Hella McVay Poetry Trail, which begins at the allée of old sycamore trees (pictured) behind the renovated barn, the Johnson Education Center. The path showcases forty-eight poems about nature as it meanders through the meadow. The park also offers playgrounds and athletic fields.

The Johnson Education Center is the home of D&R Greenway Land Trust, a central New Jersey nonprofit that strives to preserve watershed lands and large-scale landscapes. D&R Greenway organizes walks on preserved land, but visitors are also free to explore the trails independently. Check the website for scheduled walks and maps. The education center serves as a popular venue for talks, workshops, and winter farmers markets; the art galleries offer frequently changing exhibitions.

Sayen House and Gardens, Hamilton

This lovely park hidden away in Hamilton Square was once the home of Frederick Sayen and his wife Anne Mellon Sayen, who built the Arts-and-Crafts-style bungalow and designed the expansive woodland garden. The Sayens traveled throughout the world, bringing home some of the plants that still grace the property today.

Sayen Gardens is free and open to the public, and visitors are welcome to wander along the many paths and discover little ponds, fountains, and sudden bright glades. The park boasts a wide variety of plants for year-round interest, but it is especially stunning in spring when 250,000 flowering bulbs, dogwoods, redbuds, and more than 1,000 azaleas and 500 rhododendrons burst into bloom. Mother's Day is one of the busiest days at the gardens when Sayen Gardens' Azalea Festival takes place.

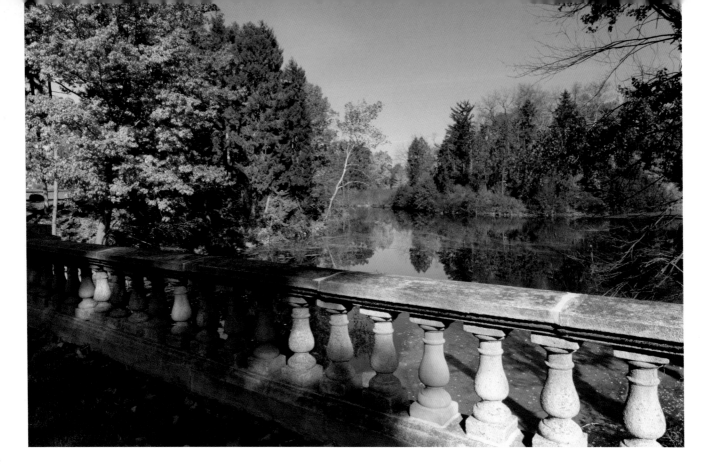

Duke Farms, Hillsborough

The Duke Farms estate was created by James Buchanan "J. B." Duke, whose family founded the immense American Tobacco Company. Duke established his estate at the end of the nineteenth century, transforming 2,200 acres along the Raritan River into a European-style park with nine lakes, winding roads, waterfalls, and numerous sculptures. His only daughter, Doris Duke, an important philanthropist, collector, and environmentalist, ensured that upon her death Duke Farms would become a habitat for native flora and fauna and be used to promote conservation and environmental protection.

Today Duke Farms is a popular year-round destination, ideal for long walks and relaxing bike rides, and offers many programs and events. From April to December an accessibility tram is available to transport visitors with disabilities throughout the park. A leader in environmental stewardship, Duke Farms boasts the LEED-Platinum Farm Barn complete with educational center and café —the perfect place to begin and end your visit.

## Stony Brook–Millstone Watershed Center and Reserve, Pennington

The Stony Brook–Millstone Watershed Reserve comprises 930 acres in Pennington and boasts miles of lovely hiking trails that traverse wetlands, forests, meadows and streams, and the sizable Wargo Pond. Other features of the reserve include the Kate Gorrie Butterfly House, where visitors can observe butterflies in various stages of development, and the new LEED-Platinum-certified nature center. Honey Brook Organic Farm, one of the largest community-supported organic farms in the country, is also at the reserve. Both center and reserve are managed by the Stony Brook–Millstone Watershed Association, founded in 1949 to protect clean water and the environment. The association runs educational programs and events throughout the year for children and adults, including stream cleanups, summer camps, and night hikes. Some of the most popular programs include a maple-sugaring lesson, complete with pancake breakfast, and the annual summer Butterfly Fest.

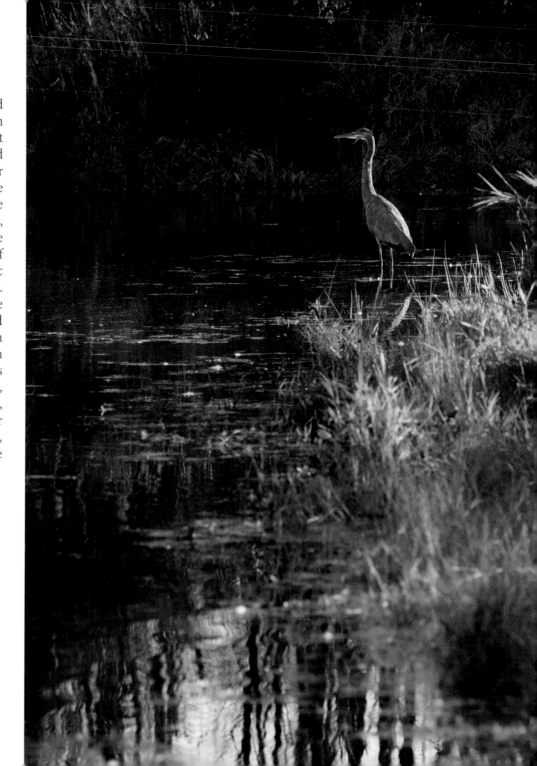

## John A. Roebling Memorial Park and Abbott Marshlands, Hamilton

The 3,000-acre area of open space between Trenton, Bordentown, and Hamilton Township encompasses the John A. Roebling Memorial Park and has recently been renamed Abbott Marshlands. The new name honors archaeologist and naturalist Charles Conrad Abbott, who discovered evidence of prehistoric human activity here in the late 1800s.

The tidal freshwater wetlands of the Delaware River were created by a rise in sea level following the end of the last glacial period. The region comprises tidal marsh, swampland, streams, and non-tidal ponds, as well as wooded uplands on higher ground, and provides critical habitats for a wide variety of plants and wildlife, some rare or endangered. Visitors can explore the area on a series of trails; the hike around Spring Lake and the island to its southwest is especially beautiful. Or one can explore by boat: there are several launch sites for canoes and kayaks.

The recently opened Tulpehaking Nature Center at 157 Westcott Avenue, Hamilton, offers changing exhibits and educational programs. Check the Abbott Marshlands' website for trail maps and information on events, guided walks, and paddling trips.

# Overview of Attractions - Nature and Gardens

This overview highlights gardens and the exploration of the natural environment. For more information on parks with extensive hiking and biking trails, see the section "Hiking, Biking, and More."

## Princeton

| | | |
|---|---|---|
| Greenway Meadows Park* | 275 Rosedale Road, Princeton | Poetry trail, playground, and playing fields. Art galleries in D&R Greenway Land Trust's Johnson Education Center |
| Institute Woods, Charles H. Rogers Wildlife Refuge* | Parking for the Institute Woods at Battlefield Park (500 Mercer Road, Princeton); refuge entrance on West Drive | Two adjacent preserves along the Stony Brook; trails for hikers; observation platforms for birders at the wildlife refuge |
| Marquand Park and Arboretum* | Main entrance and parking on Lovers Lane, Princeton; secondary entrance on Mercer Street | Shady, accessible paths and a playground with a popular sand area |
| Pettoranello Gardens in Mountain Lakes Open Space Area* | Entrance to Community Park North on Mountain Avenue, Princeton | Landscaped gardens in Princeton's "Central Park" |
| Prospect Garden* | Princeton University campus | Formal garden at rear of Prospect House |

## Cranbury

| | | |
|---|---|---|
| Plainsboro Preserve | 80 Scotts Corner Road, Cranbury | Five miles of trails through woods and around a lake; education center; bird-watching opportunities |

## Hamilton

| | | |
|---|---|---|
| Abbott Marshlands* | Several access points in Hamilton, Trenton, and Bordentown | Tidal freshwater wetlands of the Delaware River; series of hiking trails; canoeing and kayaking; nature center |
| Sayen House and Gardens* | 155 Hughes Drive, Hamilton | Elaborately landscaped woodland gardens with plenty of photo opportunities |

## Hillsborough

| | | |
|---|---|---|
| Duke Farms* | 1112 Dukes Parkway West, Hillsborough | European-style park, ideal for walking and biking; bike rental program; seasonal assistance tram; educational center offering many programs |

## New Hope, PA

| | | |
|---|---|---|
| Bowman's Hill Wildflower Preserve | 1635 River Road, south of New Hope, PA | 134-acre preserve with hundreds of native species; guided wildflower walks; programming for children and adults |

## Pennington

| | | |
|---|---|---|
| Stony Brook-Millstone Watershed Center and Reserve* | 31 Titus Mill Road, Pennington | Nature center, miles of hiking trails, year-round educational programs |

Entries with an asterisk are described more fully elsewhere in the book; please see the index as needed.

*Interaction* by
Seward Johnson
©1982 The Seward
Johnson Atelier, Inc.
Grounds For
Sculpture, Hamilton

# The Arts

The Princeton area offers an incredible array of opportunities to enjoy the literary, visual, and performing arts. In this section we focus on a handful of local institutions that are especially singular; others have already been featured in the preceding walks. All of these and more are included in the overview at the end of the section.

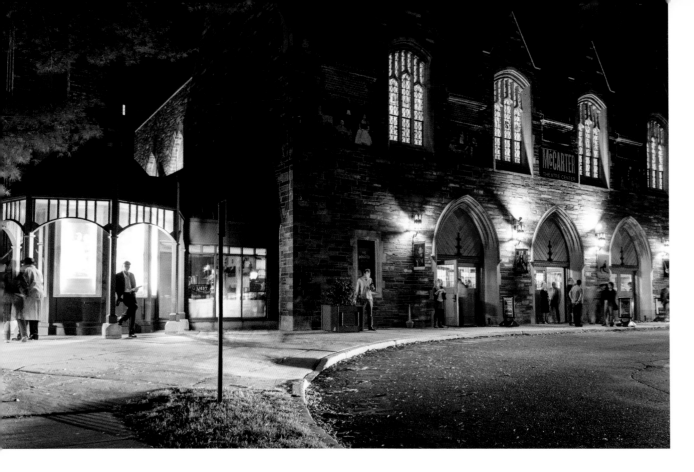

McCarter Theatre Center, Princeton

This theater was built in 1930 as a permanent home for the Princeton Triangle Club, a university theater troupe, which stages an annual musical comedy written by students for student performers and produced by professionals. The Triangle Club's performances and tours have been a beloved tradition among students and alumni for 125 years and always feature its famous all-male kickline.

The McCarter Theatre soon started showing a wide variety of first-rate artists and musicians, ranging from the French mime Marcel Marceau to the Grateful Dead. Today it is one of the most active performing arts centers in the nation with over 200 events each year. A major presenter of dramatic, musical, and dance performances by acclaimed artists from around the world, it is also a theater in its own right. Artistic director and playwright Emily Mann has overseen more than 150 productions during her tenure, one of the most famous being her adaptation of "Having Our Say," the story of the Delany sisters, which received three Tony nominations in 1995.

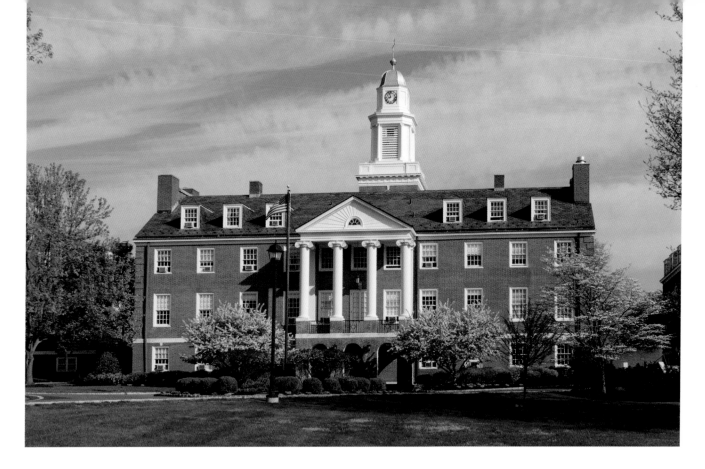

Westminster Choir College, Princeton

Princeton's musical offerings are enhanced tremendously by the presence of Westminster Choir College (WCC). Founded in 1926 in Dayton, Ohio, by well-known choral conductor John Finley Williamson, the school eventually settled in Princeton in 1932 to give students access to East Coast cities' rich musical scenes. Offering both undergraduate and graduate degrees, WCC has been recognized as a top-notch musical college and performance center for nearly a century; its choirs have sung with world-renowned orchestras including a record 350 times with the New York Philharmonic. In 1992 WCC merged with nearby Rider University, which established the Westminster College of the Arts, integrating WCC and Rider's own School of Fine and Performing Arts.

Over 400 college students prepare for careers as performers, church musicians, music educators, and arts administrators at WCC. Its choral program includes eight choirs with a wide repertoire ranging from symphonic works to sacred music and gospel. In recent years, WCC has further diversified, adding a Chinese Music Ensemble. Check the calendar for the impressive array of performances offered throughout the year. Westminster Conservatory, WCC's community music school, offers choral and instrumental opportunities for both children and adults.

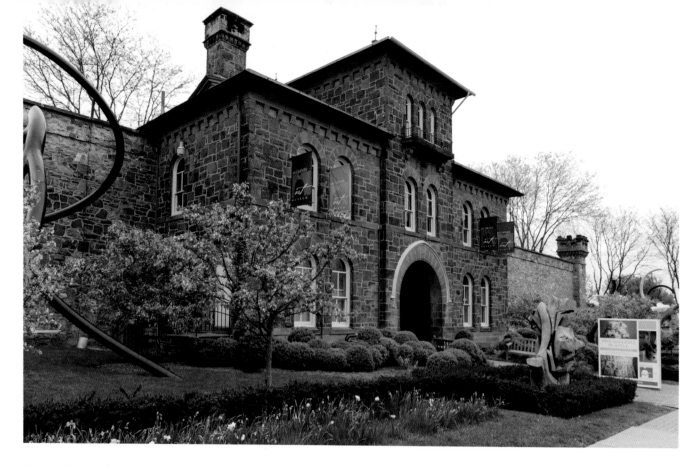

James A. Michener Museum, Doylestown, PA

Named for the award-winning author James A. Michener—a native son—this Doylestown museum focuses on acclaimed Bucks County artists. The castle-like structure was once part of the Bucks County jail; only the historic warden's house, guardhouse, and stone walls remain today, complemented by an airy, modern extension. Inside, the museum is a bright and welcoming place; its amenities include a striking outdoor sculpture garden, café with patio seating, gift shop, and children's area.

The James A. Michener Art Museum is perhaps best known for its large collection of early-twentieth-century Pennsylvania Impressionist paintings, including works by Daniel Garber and Edward Redfield. The museum also features diverse contemporary exhibitions as well as permanent displays that include works from the regional Studio Craft movement and midcentury modernists; the Nakashima Reading Room (furnished with works from the well-known woodworker's studio); and a re-creation of the office of James A. Michener. Check the calendar for information about exhibitions and a wide range of educational programs.

## Grounds For Sculpture, Hamilton

This lushly landscaped, forty-two-acre sculpture park, museum, and arboretum is at the site of the former New Jersey State Fairgrounds in Hamilton. Grounds For Sculpture was founded by philanthropist and sculptor Seward Johnson, whose life-size replicas of real people enjoying ordinary activities can be seen throughout the park along with over 270 contemporary sculptures by renowned and emerging artists. Visitors strolling along tidy paths encounter these works of art, staged among trees and shrubs. There is much to do for children as well, from climbing the bamboo observation tower to playing on the xylophone-like sculpture *Seat of Sound* by Robert Cooke. The newest part of the park is a seven-acre outdoor gallery, The Meadow. Open year-round, Grounds For Sculpture also offers changing exhibits in six indoor galleries and a robust schedule of events and activities for both adults and children, including musical and dance performances, hands-on workshops, and artist lectures. Two cafés with indoor and outdoor seating provide refreshments.

*Summer Thinking* by Seward Johnson,
©1989 The Seward Johnson Atelier, Inc.
Grounds For Sculpture, Hamilton

# Overview of Attractions - The Arts

A multitude of artists, writers, and performers—both visiting and local—contribute to Princeton's vibrant, ever-changing art scene; the list is organized by genre and venue.

## Princeton
<div align="right">Visual and Literary Arts</div>

| | | |
|---|---|---|
| Arts Council of Princeton* | 102 Witherspoon Street, Princeton | Varied performances throughout the year, changing art exhibits, classes for adults and children |
| Cotsen Children's Library | Princeton University campus, Firestone Library | Non-lending children's library features rare book displays, cozy reading nooks, and imaginative children's programs for kids of all ages |
| Labyrinth Books | 122 Nassau Street, Princeton | Full calendar of in-store author readings and lectures |
| Princeton Public Library* | 65 Witherspoon Street, Princeton | Author talks, writing workshops, book clubs for all ages, children's book festival |
| Princeton University Art Museum* | Princeton University campus | Permanent exhibits on ancient, Asian, eighteenth- to twentieth-century European and contemporary art; changing exhibits; public lectures, symposia, and many family-oriented programs |
| Princeton University Library* | Various locations on Princeton University campus | General and special collections are accessible to the public. Check the website for conditions and restrictions |

## Doylestown, PA

| | | |
|---|---|---|
| The James A. Michener Art Museum* | 138 South Pine Street, Doylestown, PA | Art museum dedicated to Bucks County artists with café and sculpture garden |

## Hamilton

| | | |
|---|---|---|
| Grounds For Sculpture* | 80 Sculptors Way, Hamilton | Expansive outdoor sculpture park with six indoor galleries, two cafés, year-round programming |

## New Brunswick

| | | |
|---|---|---|
| Zimmerli Art Museum, Rutgers University | 71 Hamilton Street, New Brunswick | Diverse collection with a focus on Russian and Soviet nonconformist art, American art, and nineteenth-century French art; special programs |

## New Hope, PA

| | | |
|---|---|---|
| George Nakashima Woodworker | 1847 Aquetong Road, New Hope, PA | Fourteen Japanese-inspired buildings on landscaped grounds; guided tours; self-guided tours on open house days |
| New Hope Arts Center | 2 Stockton Avenue, second floor, New Hope, PA | Arts center supporting local artists; regularly changing exhibits; administers public outdoor sculpture project |

## Trenton

| | | |
|---|---|---|
| Artworks | On Stockton Street, Trenton, between Front and Market Sts., off-street parking | Trenton's community arts center with exhibits, classes, and open studio space; presents the popular "Art All Night" festival in June |
| New Jersey State Museum | 205 West State Street, Trenton | Fine art collection beginning with nineteenth century; focus on American and specifically New Jersey artists |
| The Trenton City Museum at Ellarslie | In Cadwalader Park, Trenton | Permanent exhibits of art and artifacts related to Trenton's history and heritage; changing exhibits of contemporary art |

## Princeton

| | | |
|---|---|---|
| Arch Sings | Princeton University campus | Occasional performances by university a cappella groups under Blair and 1879 Arches |
| Cleveland Tower* | Graduate College, Princeton University campus | Seasonal Sunday afternoon carillon concerts |
| Institute for Advanced Study* | One Einstein Drive, Princeton | Edward T. Cone Concert Series |
| Princeton Theological Seminary* | 64 Mercer Street, Princeton | Sacred choral and instrumental concerts in Miller Chapel |
| Princeton University Chapel* | Princeton University campus | Choral concerts, lunchtime classical music performances, and musical programs representing several religious traditions |
| Richardson Auditorium in Alexander Hall* | Princeton University campus | University's primary venue for musical performances; frequent children's concerts |
| Taplin Auditorium in Fine Hall | Princeton University campus | Diverse musical performances by campus groups and visiting ensembles |
| Westminster Choir College* | 101 Walnut Lane, Princeton | Wide array of concerts, ranging from symphonic works to sacred music to gospel, performed by students and faculty throughout the year |

## Princeton

| | | |
|---|---|---|
| Hamilton Murray Theater at Murray-Dodge Hall | Princeton University campus | Venue of the student-run Theatre Intime and Princeton Summer Theater |
| Lewis Center for the Arts* | Various venues on Princeton University campus, mainly at 185 Nassau Street and the arts complex off University Place | Wide array of public performances, exhibitions, readings, film screenings, and lectures |
| McCarter Theatre Center* | 91 University Place, Princeton | Over 200 shows per year; both a producing theater and major venue for a wide variety of productions (music, comedy, dance, circus) |
| Princeton Garden Theatre* | 160 Nassau Street, Princeton | Downtown movie theater specializing in art, independent, and classic films |

## New Brunswick

| | | |
|---|---|---|
| George Street Playhouse | 9 Livingston Avenue, New Brunswick | New Brunswick playhouse stages new and established plays |
| State Theatre New Jersey | 15 Livingston Avenue, New Brunswick | Elegant, restored vaudeville theater offers a wide array of concerts and plays as well as comedy and dance performances |

## Titusville

| | | |
|---|---|---|
| Washington Crossing Open Air Theatre | 455 Washington Crossing-Pennington Road, Titusville | Seasonal open air theater performances for children and adults at Washington Crossing State Park |

## Trenton

| | | |
|---|---|---|
| Mill Hill Playhouse | 205 East Front Street, Trenton | Small theater in an old church building at the edge of the Mill Hill neighborhood |
| Trenton Circus Squad | 675 South Clinton Avenue, Trenton; parking at the shopping center | Public events and citywide performances by youth circus troupe; classes for children and adults |

## West Windsor

| | | |
|---|---|---|
| Kelsey Theatre at Mercer County Community College | 1200 Old Trenton Road, West Windsor | Community theater presents classic shows for both children and general audiences |

Entries with an asterisk are described more fully elsewhere in the book; please see the index as needed.

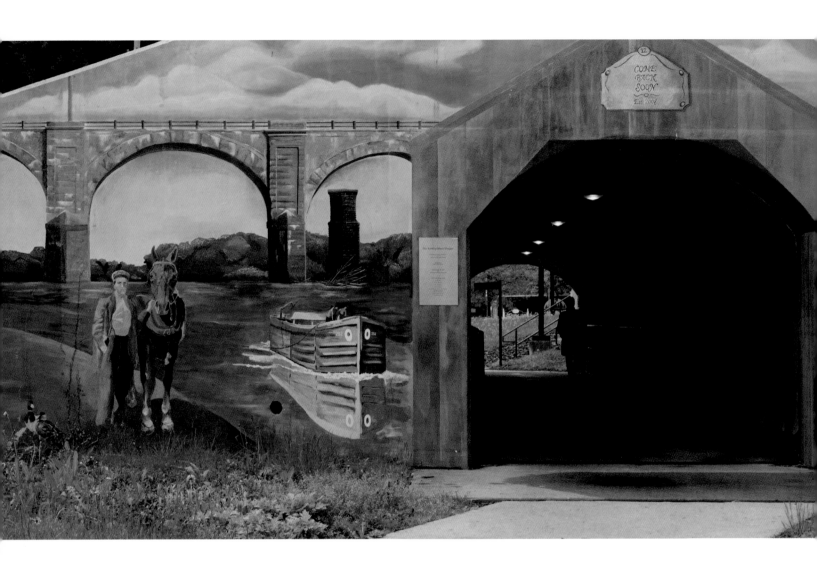

The Yardley Mural Project, Yardley, Pennsylvania

## Hiking, Biking, and More

There are plenty of options for outdoors enthusiasts in the greater Princeton area, whether it be kayaking, mountain biking, hiking, or even bouldering. Visit these parks and preserves in different seasons to fully appreciate the area's natural beauty.

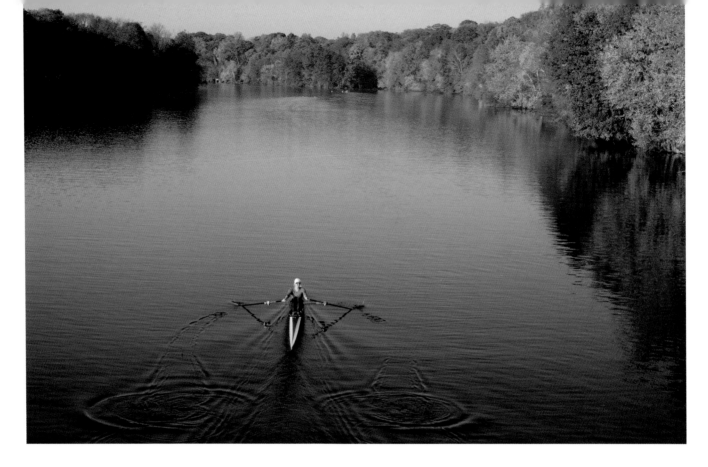

Carnegie Lake, Princeton

"O, what a place for a lake!" Andrew Carnegie allegedly exclaimed when, inspired by the painter Howard Russell Butler, he viewed the site of future Carnegie Lake and decided to finance the project for the university's rowing program. The second famous quotation associated with the creation of Carnegie Lake belongs to Woodrow Wilson: he would have preferred funds for the university's graduate and preceptorial programs and is said to have uttered, "We needed bread and you gave us cake!" (*PWB*, April 3, 2006).

The project proved a lot more costly (almost four times!) than estimated, but by 1906 the land had been purchased and excavated by hand, bridges and dams had been built, and Princeton had a lake.

Rowers from both university and community can often be seen on the lake, practicing and racing. The lake also offers public boat launches, bird watching, and fishing. In winter the whole community closely watches the flags, which signal whether the ice is safe for skating.

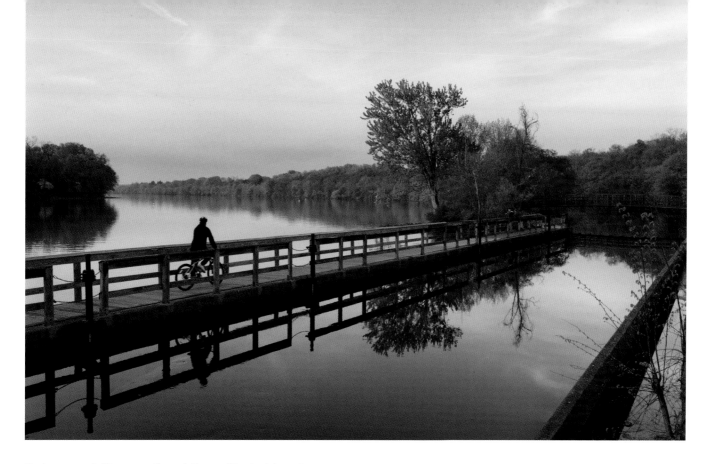

Delaware & Raritan Canal State Park, New Jersey

Once one of the most important transportation routes between Pennsylvania and New York, the Delaware and Raritan Canal, along with a narrow strip of land on both banks, was converted into a state park in the 1970s. This seventy-mile greenway now stretches from Frenchtown south to Trenton and from there to New Brunswick with many access points along the way.

The Delaware & Raritan Canal State Park offers something for everyone. The mile-long towpaths along the canal are typically busy with hikers, joggers, and bikers; fishing, canoeing, and kayaking are also popular options. History and canal enthusiasts will enjoy the reminders of times past: nineteenth-century tender houses and remnants of locks, along with many informative signs. Birds abound as the park not only provides a recreational corridor for humans, but also a haven for wildlife. The Millstone aqueduct (pictured) conveys water from the canal over the Millstone River and Lake Carnegie, and offers an especially lovely and peaceful spot for bird-watching.

## Sourland Mountain Preserve, Hillsborough

The Sourlands, stretching from Hillsborough to Lambertville, are dominated by the impressively named Sourland Mountain, a long, forested ridge rising abruptly from the surrounding fields—albeit only to a height of about 500 feet above sea level.

Sourland Mountain Preserve is at the northeastern tip of the ridge, 4,000 acres of preserved land offering a habitat for a variety of plants and animals and plenty of recreational opportunities. Trails leading through the boulder-strewn forest are open to hikers, mountain bikers, and horseback riders. Bouldering is also allowed.

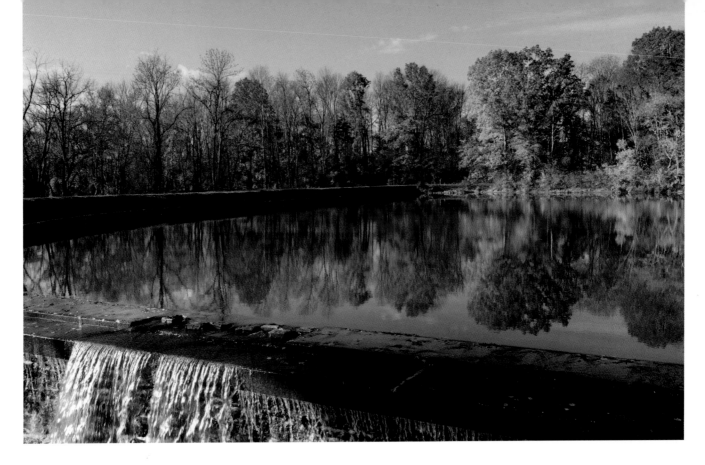

Mountain Lakes Open Space Area, Princeton

At the end of the nineteenth century, before the advent of refrigerators, a set of lakes was created to harvest ice blocks for Princeton's homes. Today they are the centerpiece of a 400-acre green space just north of downtown, encompassing not only the Billy Johnson Mountain Lakes Preserve but also Mountain Lakes North, the John Witherspoon Woods, and Community Park North. A contiguous system of hiking trails leads around the lakes, along streams, through forest, and across boulder fields. A boardwalk along the edge of historic Coventry Farm connects the park to Great Road and Farm View Fields.

Mountain Lakes House overlooks the lake and is home to Friends of Princeton Open Space, a nonprofit that has been active in helping preserve open space in the Princeton area for almost fifty years.

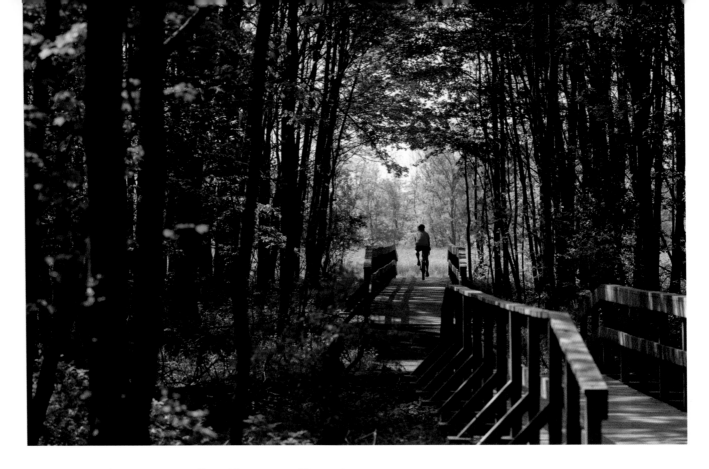

Mercer Meadows, Hopewell and Lawrence Townships

A peaceful morning bike ride is a good way to enjoy Mercer Meadows, an expanse of grasslands and forests punctuated by lakes and ponds. A series of well-marked trails—including the Lawrence-Hopewell Trail—connects this recently unified set of green spaces north of Lawrenceville. Today's meadows were once fields and also the site of AT&T's "pole farm," the complex of radio antennas that transmitted the nation's international calls until the 1960s. The 1,600-acre park provides a haven for wildlife, and the Mercer County Park Commission has installed several observation towers and nature blinds for better viewing. Other attractions at Mercer Meadows include Rosedale Lake, where you can canoe and fish as well as enjoy picnic areas, playgrounds, and an off-leash dog park. Horseback riding is allowed at the Equestrian Center and on designated trails.

The twenty-two-mile Lawrence-Hopewell Trail is a bicycle and pedestrian path that loops through Hopewell and Lawrence townships, across park lands as well as corporate and school campuses. This popular route gives residents the option to walk or bike to work.

# Overview of Attractions - Hiking, Biking, and More

This list suggests opportunities for longer hikes and more strenuous exercise. Additional parks and preserves are listed in the section "Nature and Gardens."

## Princeton

| | | |
|---|---|---|
| Carnegie Lake* | Multiple access points in Princeton and West Windsor | Scenic lake for rowing, fishing, canoeing, kayaking, and ice skating. Lined by walking/jogging/ biking path |
| Delaware & Raritan Canal State Park* | See website for multiple access points to the park | Hiking and biking on canal towpaths; rental canoes and kayaks available at two sites near Princeton; fishing |
| Herrontown Woods Arboretum | Off Snowden Lane, Princeton | Three miles of hiking trails through 140 acres of hilly woods |
| Mountain Lakes Open Space Area* | Several access points in Princeton (Mountain Avenue, Stuart Road, Great Road, Cherry Hill Road) | Hiking, biking, and walking paths through woods, boulder fields and around lake |
| Woodfield Reservation | Main entrance off the Great Road, Princeton | Two miles of little-trod trails through mature, forested land of Princeton Ridge; two interesting rock features |

## Franklin Township

| | | |
|---|---|---|
| Six Mile Run Reservoir Site | One of several access points on Canal Road, Franklin Township, just before the intersection with Blackwells Mills Road | Ten miles of trails open to bikers, hikers and equestrians; some paths with man-made obstacles for mountain bikers |

## Hamilton

| | | |
|---|---|---|
| Mercer County Park | Main entrance off Hughes Drive, Hamilton | 2,500-acre park with paths for walking, hiking, and biking; rowing on the lake; ice skating rink; several playgrounds; disc golf course; playing fields |

## Hillsborough

| | | |
|---|---|---|
| Sourland Mountain Preserve* | 421 East Mountain Road, Hillsborough | Preserve at the northeastern tip of the forested ridge; open to hikers, mountain bikers, and equestrians; bouldering options |

## Hopewell and Lawrence Townships

| | | |
|---|---|---|
| Mercer Meadows* | Multiple access points in Hopewell and Lawrence Townships | 1,600-acre park of meadows and young forest; network of trails; picnic areas; playgrounds; equestrian center; dog park |

## Titusville

| | | |
|---|---|---|
| Washington Crossing State Park, New Jersey* | 355 Washington Crossing-Pennington Road, Titusville | Trails for hiking, biking, and horseback riding; nature center; visitor center museum on Revolutionary War; summer performances at the Open Air Theater |

Entries with an asterisk are described more fully elsewhere in the book; please see the index as needed.

## Local Food

As its nickname "The Garden State" suggests, New Jersey remains home to more than 9,000 farms and ranks among the leaders in the production of blueberries, cranberries, spinach, bell peppers, and peaches. Several farms in the Princeton area offer pick-your-own produce options during the summer and fall as well as community-supported agriculture programs. To attract visitors, many farms offer a wide range of programs and activities, from summer camps to canning classes to fancy farm-to-table dinners. And while you can expect to find New Jersey's traditional crops at most local farms and the host of farmers markets that have cropped up over the last decade, some growers are branching out to suit new customers and palates by cultivating ginger, rice, and other specialty foods.

# Overview of Attractions - Local Food

We have included a short list of local farms and farmers' markets below, but there are plenty of other farms in the vicinity that offer community-supported agriculture programs and onsite farm stands.

| Farms | | |
|---|---|---|
| Blue Moon Acres | 11 Willow Creek Drive, Pennington | Quaint farm store stocked with high-quality, local artisanal goods and produce; seasonal workshops and events |
| Cherry Grove Farm | 3200 Lawrenceville Road, Lawrenceville | Fresh local eggs and dairy products, general store, daily views into the milking parlor, workshops and events |
| Lee Turkey Farm | 201 Hickory Corner Road, East Windsor | Seasonal pick-your-own veggies and fruits; turkeys (fresh in fall or frozen year-round) raised by sixth-generation farmers; harvest festival |
| Terhune Orchards | 330 Cold Soil Road, Princeton | Seasonal pick-your-own fruits and veggies, on-site wine-tasting room, farm store, family-friendly events throughout the year |

| Farmers Markets | |
|---|---|
| Montgomery Friends of Open Space Farmers Market | 1340 Route 206, Skillman |
| Princeton Farmers Market | Hinds Plaza, 55 Witherspoon Street, next to Princeton Public Library, Princeton |
| Trenton Farmers Market (indoor, year-round) | 960 Spruce Street, Lawrence Township |
| West Windsor Community Farmers Market | 2 Vaughn Drive, Princeton; parking lot at Princeton Junction train station |

## The Sciences

Since its early days, New Jersey has been fertile ground for inventors and scientists. Innovator John Stevens (1749–1838) built and ran the first steam locomotive on his estate. Thomas Edison (1847–1931), dubbed the "wizard of Menlo Park" (New Jersey), invented the phonograph and the all-important electric light bulb. Less well-known, but nearly as important for many of us, was Earle Dickson (1892–1961), designer of the Band-Aid. After World War II, New Jersey came to be known as the "Research State," and Mercer County its hub. Today it is sometimes called the "world's medicine chest" because of the large number of pharmaceutical companies that either began there or have relocated to New Jersey. Given this rich history, it is no surprise that Princeton and the surrounding areas boast a wealth of programs and several museums that inspire both children and adults to engage with science.

Segment of a stellarator at the Princeton Plasma Physics Laboratory

# Overview of Attractions - The Sciences

Most of the educational institutions in the area (e.g. Princeton University, Princeton Theological Seminary, Institute for Advanced Study, Rutgers University, Rider University, The College of New Jersey) offer a variety of lectures and programs open to the public; check their websites for the most current information.

## Princeton

| | | |
|---|---|---|
| Peyton Observatory | Princeton University campus, Department of Astrophysical Sciences | Monthly open house to observe the night sky |
| Princeton Plasma Physics Laboratory | 100 Stellarator Road, Princeton | Bimonthly public tours, Science on Saturdays program in winter, weekly scientific colloquia |
| Princeton Public Library* | 65 Witherspoon Street, Princeton | Frequent science-related programs and lectures for children and adults |
| Princeton University | Various locations on campus | Regular science-related programs and science demonstrations for kids (visit the website of the Office of Community and Regional Affairs, Princeton University for more information) |

## Cherry Hill

| | | |
|---|---|---|
| Garden State Discovery Museum | 2040 Springdale Road, Suite 100, Cherry Hill | Children's museum; imaginative play spaces, science-related exhibits, and hands-on activities for young children |

## Ewing

| | | |
|---|---|---|
| The Sarnoff Collection | The College of New Jersey, Ewing; second floor of Roscoe West Hall | Museum dedicated to David Sarnoff and RCA Victor Company's innovative communications technologies (radio, recording, television, computers, electron microscopes) |

## Jersey City

| | | |
|---|---|---|
| Liberty Science Center | 222 Jersey City Boulevard, Jersey City | Permanent and traveling exhibitions on wide array of scientific topics; IMAX and 3D movies; café |

## Morristown

| | | |
|---|---|---|
| Morris Museum | 6 Normandy Heights Road, Morristown | Expansive collection of mechanical instruments and automata; other exhibits ranging from Native American artifacts to minerals |

## Trenton

| | | |
|---|---|---|
| New Jersey State Museum | 205 West State Street, Trenton | Science exhibits, planetarium shows |

## West Orange

| | | |
|---|---|---|
| Thomas Edison National Historical Park, West Orange | 211 Main Street, West Orange | Edison's largest laboratory complex; three floors of the main laboratory building are preserved and open to the public; nearby is Glenmont Estate, Edison's home |

Entries with an asterisk are described more fully elsewhere in the book; please see the index as needed.

# Selected Bibliography

Axtell, James. *The Making of Princeton University: From Woodrow Wilson to the Present.* Princeton, NJ: Princeton University Press, 2006.

Barnett, Robert Spencer. *Princeton University and Neighboring Institutions, The Campus Guide, Second Edition.* Princeton, NJ: Princeton Architectural Press, 2015.

Breese, Gerald. *Princeton University Land 1752-1984.* Princeton, NJ: Princeton University Press, 1986.

Brockmann, R. John. *Commodore Robert F. Stockton, 1795-1866: Protean Man for a Protean Nation.* Amherst, NY: Cambria, 2009.

Burt, Nathaniel. "The Princeton Grandees." *Princeton History: The Journal of the Historical Society of Princeton,* no. 3 (1982): 1–28.

Cotton, Dale. *Princeton Modern: Highlights of Campus Architecture From the 1960s to the Present.* Princeton, NJ: Princeton University Office of Communications, 2010.

Cuyler, Lewis B. "Origins of the Delaware and Raritan Canal." *Princeton History: The Journal of the Historical Society of Princeton,* no. 4 (1983): 1-16.

Ebner, Michael H. "Experiencing Megalopolis in Princeton." *The Journal of Urban History* 19, no. 2 (Feb. 1993): 11–55.

Evans, William K. *Princeton: A Picture Postcard History of Princeton and Princeton University.* Vestal, NY: Almar, 1993.

Gambee, Robert G. *Princeton Impressions.* New York: Norton, 2011.

Gooding, Cynthia. *A Princeton Guide: Walks, Drives and Commentary.* Somerset, NJ: Middle Atlantic, 1971.

Gottmann, Jean. *Megalopolis: The Urbanized Northeastern Seaboard of the United States.* New York: Twentieth Century Fund, 1961.

Greiff, Constance M. "Bainbridge House." *Princeton History,* no. 1 (1971): 9–23.

—, Mary M. Gibbons and Elizabeth G.C. Menzies. *Princeton Architecture: A Pictorial History of Town and Campus.* Princeton, NJ: Princeton University Press, 1967.

—, and Wanda S. Gunning. *Morven: Memory, Myth & Reality.* Princeton, NJ: Historic Morven, Inc., 2004.

Hageman, John F. *History of Princeton and Its Institutions.* 2 vols. Philadelphia: J. B. Lippincott, 1879.

Hand, Susanne. "Moved Buildings in Princeton." *Princeton History: The Journal of the Historical Society of Princeton,* no. 15 (1998): 59–80.

Hobler, Randy and Jeanne Silvester. *On The Streets Where We Live.* [Princeton, NJ]: R. Hobler and J. Silvester, [1990].

Jerome, Fred and Rodger Taylor. *Einstein on Race and Racism.* New Brunswick, NJ: Rutgers University Press, 2005.

Knox, Nancy. "Princeton Basin." *Princeton History: The Journal of the Historical Society of Princeton,* no. 4 (1983): 17–27.

Leitch, Alexander. *A Princeton Companion.* Princeton, NJ: Princeton University Press, 1978.

Lockwood, William W. *Celebrating 75 years: 1930–2005.* [Princeton, NJ]: McCarter Theatre Center, [2005].

Maynard, W. Barksdale. *Princeton: America's Campus.* University Park, PA: Pennsylvania State University Press, 2012.

Menago, Marilyn. *Princeton: History and Architecture.* Atglen, PA: Schiffer Publishing, 2007.

Moorhead, James H. *Princeton Seminary in American Religion and Culture.* Grand Rapids, MI: William B. Eerdmans, 2012.

Oberdorfer, Don. *Princeton University: The First 250 Years.* [Princeton, NJ]: The Trustees of Princeton University, 1995.

Rhinehart, Raymond P. *The Campus Guide: Princeton University.* New York: Princeton Architectural Press, 1999.

Root, Robert K. *The Princeton Campus in World War II.* Edited by Jeremiah S. Finch. Princeton, NJ: [s.n.], 1978.

Seasonwein, Johanna G. *Princeton and the Gothic Revival, 1870-1930.* Princeton, NJ: Published by the Princeton University Art Museum and distributed by the Princeton University Press, 2012.

Selden, William K. *Princeton Theological Seminary; A Narrative History, 1812-1992.* Princeton, NJ: Princeton University Press, 1992.

—. *Women of Princeton, 1746-1969.* Princeton, NJ: Princeton University Press, 2000.

Smith, Richard D. *Images of America: Princeton.* Charleston, SC: Arcadia, 1997.

—. *Legendary Locals of Princeton.* Charleston, SC: Arcadia, 2014.

—. *Princeton.* Charleston, SC: Arcadia, 2007.

Washington, Jack. *Long Journey Home.* Trenton, NJ: Africa World, 2005.

Wertenbaker, Thomas Jefferson. *Princeton, 1746-1896.* Princeton, NJ: Princeton University Press, 1946.

## Selected Internet Resources

*The Daily Princetonian.* www.dailyprincetonian.com.
Institute for Advanced Study. www.ias.edu.
*Princeton Alumni Weekly.* www.paw.princeton.edu.
Princeton Theological Seminary. www.ptsem.edu.
Princeton University. www.princeton.edu.
Princeton University Library Digital Archives. www.theprince.princeton.edu (*Local Express, Princeton Weekly Bulletin, The Daily Princetonian, Town Topics*).

# Index

JAN -- 2018